# ON THE EDGE

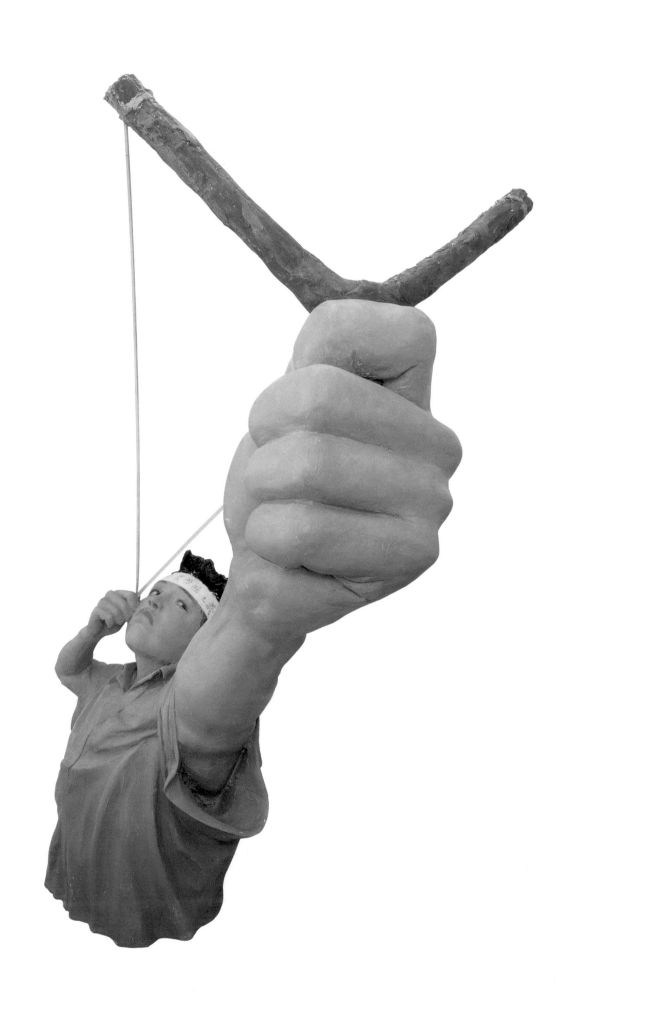

# ON THE EDGE

## Contemporary Chinese Artists Encounter the West

**Britta Erickson**

**Iris & B. Gerald Cantor Center for Visual Arts at Stanford University**

**On the Edge: Contemporary Chinese Artists Encounter the West** is published in conjunction with the exhibition organized by the Iris & B. Gerald Cantor Center for Visual Arts at Stanford University.

**Itinerary**
Cantor Arts Center, Stanford University: January 26–May 1, 2005
Davis Museum and Cultural Center, Wellesley College: February 13–June 3, 2006
Indianapolis Museum of Art: July 2–September 24, 2006

"On the Edge" was organized by the Cantor Arts Center at Stanford University. The exhibition, catalogue and related programs at Stanford University are made possible through the generosity of Karen Christensen; an anonymous donor; the Shenson Exhibitions Fund; the Center for East Asian Studies, the Office of the Dean of the School of Humanities and Sciences, and the Department of Art and Art History at Stanford University; The Christensen Fund; the J. Sanford and Constance Miller Fund; Linda and Tony Meier; Rex Vaughan; Jean-Marc Decrop; and Eloisa and Chris Haudenschild.

Front cover: Zhang Huan, *My New York*: #4, 2002.
Frontispiece: Wang Du, *Youth with Slingshot*, 2000.

Library of Congress Cataloguing-in-Publication Data:
Erickson, Britta.
On the edge : contemporary Chinese artists encounter the West / Britta Erickson.
    p. cm.
Exhibition catalog.
Includes bibliographical references and index.
ISBN 0–937031–26–7 (pbk. : alk. paper)
1. Art, Chinese – 20th century – Exhibitions. 2. East and West – Exhibitions. I. Title.

N7345.E75 2004
709.'51'07479473–dc22

2004054625

ISBN 988–98086–5–x  (Timezone 8)
ISBN 0–937031–26–7 (Cantor Arts Center)

Guest curator: Britta Erickson
Coordinating curator: John Listopad, Patrick J. J. Maveety Curator of Asian Art
Cantor Arts Center editor: Bernard Barryte, Chief Curator
Edited and indexed by Frances Bowles
Designed and printed by Zhang Nian Studio and Timezone 8 Ltd
28/F, No. 3 Lockhart Road
Wanchai, Hong Kong
www.timezone8.com

Printed and bound in China

Iris & B. Gerald Cantor Center for Visual Arts
328 Lomita Dr.
Stanford, CA 94305-5060 USA
www.stanford.edu/dept/ccva

Photography Credits
Photographs of works of art are reproduced by permission of the artists. Additional credits are noted below:
Fig. 1. Courtesy of the Art Museum, The Chinese University of Hong Kong
Fig. 2. Courtesy of the Iris & B. Gerald Cantor Center for Visual Arts, Stanford University
Fig. 10. Courtesy of Wang Keping and Hanart T Z Gallery, Hong Kong
Fig. 28. Rong Rong
Fig. 35. Stephanie Tasch
Fig. 41. Elio Montanari
Fig. 55. L. Lecat
Figs. 62–67. Courtesy of Xing Danwen/SCALO/Meredith Palmer Gallery Ltd.
Fig. 96. Courtesy of the Shanghai Museum
Fig. 113. Song Dong

A Note to the Reader
The names of all the Chinese artists in this catalogue are rendered in the Chinese manner: surname followed by given name. The one exception is Wenda Gu, who moved to the United States in 1987 and prefers to express his name in the Western manner, surname last.

# CONTENTS

# FOREWORD

In organizing *On the Edge: Contemporary Chinese Artists Encounter the West*, the Iris & B. Gerald Cantor Center for Visual Arts at Stanford joins the growing number of art institutions in the West that recognize the vitality of contemporary Chinese art, and the significant contributions Chinese artists are making toward a new globalized art milieu. The exhibition marks the first step toward a larger presence for contemporary art at the Cantor Center and reflects Stanford University's continuing emphasis on the importance of the Pacific Rim and China.

The works in *On the Edge* represent the reactions of leading Chinese artists to encounters with the West. Some are contemplative musings on the space that opens up when one culture is observed from the vantage point of another. Others are confrontational comments on Western dominance in the process of globalization. Some take strategic advantage of an outsider position. Each is symptomatic or expressive of the relationship between China and the West. During the 1990s and into the new millennium, many exhibitions of contemporary Chinese art in the West have presented Chinese art as a homogeneous monolithic entity, or have concentrated on art that is clearly tied to China's great traditions of painting and calligraphy. Both approaches have packaged Chinese art in ways that validate Western preconceptions, so that a surfeit of such exhibitions has contributed to Chinese art's liminality. We are confident that this situation is changing. The approach taken by this exhibition arises forcefully from the art itself, rather than being imposed from without.

This exhibition and catalogue are the creation of the guest curator Dr. Britta Erickson who, since completing her doctorate at Stanford, has become one of the foremost scholars of contemporary Chinese art. This is her second major exhibition to be presented in the United States of America, and her most ambitious. All the staff of the Cantor Arts Center are grateful for Britta's insights, energy, and collegiality as she developed the exhibition.

Among the numerous individuals who have contributed to the success of *On the Edge*, we must first thank the artists and collectors who have so generously loaned works of art to the exhibition. The three artists who graciously allowed us to reproduce important texts as appendixes to the catalogue deserve special recognition. Others, too numerous to name, have contributed in myriad ways. Those who went to particular lengths include Johnson Chang, Ethan Cohen, Francesca Dal Lago, Jean-Marc Decrop, Deitch Projects, Feng Bin, Michael Goedhuis,

Martina Köppel-Yang and Yang Jiechang, Alexander Ochs, Uli Sigg, and most notably Lorenz Helbling and Zhang Zhaohui. Special thanks are owed to Kela Shang, for assistance with correspondence, and to Stephen Whiteman, for help in editing the appendixes.

The talented staff of the Cantor Arts Center has developed this project with Britta Erickson. Dr. John Listopad, Maveety Curator of Asian Art, has been of great assistance in coordination with Dr. Erickson. Bernard Barryte has directed the development and production of this handsome catalogue, which was designed and printed by Timezone 8, based in Hong Kong. Mona Duggan, with Holly Bieniawski, has overseen fundraising, and Anna Koster has promoted the exhibition, ensuring public awareness of its importance. Sarah Miller and Noreen Ong have been instrumental in the details of the loans, budget, and presentation, and our capable preparators have installed the exhibition with their customary high standards of care.

There is more to this project than an exhibition and catalogue. Many of the artists will be guests at Stanford University and will participate in a course on contemporary Chinese art organized by our faculty colleagues, including Richard Vinograd, from the Department of Art and Art History, and Jean Oi and Lydia Chen, from the Center for East Asian Studies. There will also be a symposium at Stanford during the run of the exhibition.

We are delighted to be sharing this exhibition with two other American museums. I am grateful to David Mickenberg, Director of the Davis Museum and Cultural Center at Wellesley College, and his colleague Professor Heping Liu, who gave their enthusiastic support to this endeavor. At the Indianapolis Museum of Art, Anthony Hirschel, Director, and Sue Ellen Paxson have been enthusiastic about hosting this exhibition and have adjusted their schedules around their remodeling to accommodate its presentation. I am grateful to the staff and trustees of both institutions for their support and enthusiasm.

Funding a complex contemporary exhibition that has controversial elements can be difficult. I am therefore extremely grateful for the generosity of the Shenson Exhibitions Fund, the Center for East Asian Studies, the Office of the Dean of the School of Humanities and Sciences at Stanford University, the J. Sanford and Constance Miller Fund, Linda and Tony Meier, Rex Vaughan, Jean-Marc Decrop, and Eloisa and Chris Haudenschild for their support of the exhibition.

Finally, thanks to Britta Erickson for her insights and for her determination to make this special project both beautiful and engaging.

Thomas K. Seligman
John and Jill Freidenrich Director

# INTRODUCTION

Art and politics are inseparable. Chinese artists in their forties absorbed this notion during their adolescence, when Mao's theories on art shaped the visual landscape. A younger generation of artists has become obsessed with a particular blend of art and politics—of cultural politics—focusing on the positioning of Chinese art within the global art scene.

Although the situation has been improving rapidly, for many years China's avant-garde artists were doubly marginal: the art of China has been considered marginal by the international art community centered in the West, and the artists themselves were marginalized in their own country, a situation that has given many of them a heightened appreciation of the nuances of their tenuous acceptance. The result is the creation of a large body of bold experimental works dissecting the artist's position in the art world and China's position in the political world: art and politics are inseparable. Many of the most notable or provocative works in this vein are included in *On the Edge*, an exhibition focusing on this topic.

## Part One: The West through a Political Lens

Five of the artists represented in this exhibition live overseas; seven remain in China. Whether observing interactions between China and the West from within China or without, all are enthralled by the current events gripping the popular consciousness. Through wackily distorted world maps, Hong Hao presents his views of international power balances; Xing Danwen looks at the effects of globalization on Chinese villagers; Zhang Huan reflects on the spirit of New York in the wake of the terrorist attacks on the World Trade Center in 2001; and three artists examine two events that galvanized the Chinese, the NATO bombing of the Chinese Embassy in Belgrade, during the war in the former Yugoslavia, and the forced landing of an American spy plane in south China.

## Part Two: Cultural Mélange

What do people see when they look from China to the West? Qiu Zhijie's interactive CD-ROM allows exhibition visitors to explore Chinese ideas of the

West, ideas that range from absurd or shocking popular misconceptions to historical views. Xu Bing uses language to explore the intersection of East and West and to create a middle ground where the two can meet—a classroom set up in the museum. Zhang Hongtu demonstrates that, if people can find a way to position themselves outside their accustomed cultural milieu, they can gain a clearer understanding of it.

### Part Three: Joining the Game: The Chinese Artist Meets the World

Throughout the 1990s, Chinese artists fought for a toehold in the international art world. To achieve parity while avoiding the commodification of difference—and while remaining in China—was at first a difficult goal, in a realm largely controlled by Western curators and critics. Some artists living in China have reacted by producing bitingly humorous pieces commenting on these circumstances. Yan Lei and Zhou Tiehai, in particular, have taken the situation as both subject and medium for numerous works of art, pushing at and playing off the Western art establishment.

### Appendixes

The catalogue includes three appendixes, each a complete document in itself. The first, *Bat Project History*, records Huang Yong Ping's repeated efforts to build life-sized replicas of portions of the American spy plane forced to land on Hainan Island in China. He built three sections of the airplane, each time encountering censorship from unexpected directions. The second, *Introduction to Square Word Calligraphy*, is an abbreviated edition of the book Xu Bing designed to teach his new way of writing. The third, *Will*, is a film script illustrated with paintings by Zhou Tiehai. The film sardonically chronicles the travails of a group of artists trying to make their way into the international art circuit.

# A FLEETING INTRODUCTION TO CONTEMPORARY CHINESE ART

The Chinese art world has undergone an extraordinary metamorphosis over the past three decades. The purpose of art, the means of production, the social status of the artist, and the level of engagement with the international art world have all changed dramatically. Whereas Chinese artists now work with a plethora of media, ranging from traditional brush and ink to video and multimedia installation, and participate in prominent international exhibitions, thirty years ago political circumstances severely constrained their options and opportunities.

Two aspects of twentieth-century Chinese history have done much to shape recent Chinese art. First, politics and art became increasingly and inextricably intertwined through the first seven decades of the century and the legacy is an ingrained tendency to inject social commentary into art. Second, many of today's midcareer artists came of age during the tumultuous decade of the Great Proletarian Cultural Revolution (1966–1976), which gave them a singular outlook on life and on the role of art. For these reasons, a brief review of the history of Chinese art from the start of the twentieth century will enrich our understanding of the works included in *On the Edge: Contemporary Chinese Artists Encounter the West.*

## The Early Twentieth Century

The extreme turmoil of modern Chinese history inevitably did much to shape twentieth-century Chinese art. Waves of upheaval swept China throughout the century, as different political factions attempted to gain— and maintain—control. Weakened by the combined forces of large-scale corruption, Western incursions, numerous rebellions, and general moral bankruptcy, the Qing dynasty, which had begun in 1644, collapsed in 1911, ending millennia of imperial rule. The Republican Period that followed (1911–1949) saw China through the two world wars (1914–1918 and 1939–1945), the horrific Sino-Japanese War (1937–1945), during which twenty million Chinese were killed, and recurring battles among independent warlords, the army of the ruling Nationalist Party, and the Chinese Communist Party led by Mao Zedong (1893–1976). In 1949 the Nationalists retreated to Taiwan, leaving the Communists to establish the People's Republic of China. Most of the subsequent upheavals have resulted from government policy: the Great Leap Forward in 1958, with its ill-considered mass collectivization programs, led to large-scale famine (thirty million people starved to death), and between 1966 and 1976 the Cultural Revolution brought persecution to the millions who fell into politically undesirable categories. Chinese society has continued to change dramatically, but since 1976 these transformations have been driven largely by revolutions in economic policy: during the past three decades China has evolved from an isolated socialist state engaged in extremely limited international commerce to an outward-looking nation with the fourth-largest volume of international trade.

Many early twentieth-century thinkers in China believed that the country could resist Western incursions only through mastery of such practical aspects of Western learning as science and technology. Paralleling this, cultural figures promoted realism in art, believing that a focus on the real world, rather than on the abstract intellectual exercise of manipulating brush and ink in traditional painting, would strengthen the nation. Frequently throughout the twentieth century, art movements have been linked to political movements. Artists of the Lingnan School in Guangzhou, for example, advocated a style of brush and ink painting that incorporated modern subject matter (such as airplanes; fig. 1) and such Western techniques as chiaroscuro. In keeping with their artistic preferences, they maintained close ties with the Nationalists, who sought to modernize China after a more-or-less Western model. It was the Communists, however, who made the most astute and varied use of art as a political tool.

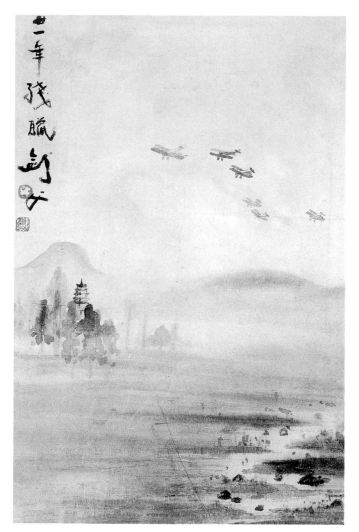

Fig. 1. Gao Jianfu, *Flying in the Rain*, 1932.
Hanging scroll, ink and color on paper, 46 x
35.5 cm. Collection of the Art Museum,
The Chinese University of Hong Kong.

They promoted a woodcut movement, beginning in
the 1930's, Socialist Realism from the time of the
Great Leap Forward, peasant painting from the 1950s
into the 1970s, and revolutionary ballets and operas
(among other things) during the Cultural Revolution.
With their bold and incisive lines (fig. 2), woodcuts
could capture the horrors of war, and their method of
production allowed for widespread dissemination.
Socialist Realist oil paintings asserted the power of the
communist government in a grandiose and emotional
manner, and were suitable for decorating the many
new public buildings that were being erected at the
time. Peasant paintings affirmed the notion that the
best art was that produced by "the people." Overseas
exhibitions of peasant painting were a cultural adjunct
to the Ping-Pong diplomacy of the 1970s, offering a
window into what was then a mysterious sealed-off
nation.[1] The revolutionary ballets and operas of the
late 1960s were pure propaganda recast as grand
spectacle (fig. 3), at a time when public
entertainment was extremely sparse.

Cultural mavens rationalized the redirection of art
through reference to Mao Zedong's series of lectures
in 1942 on the role that art and literature should play in
China's communist revolution. These lectures, the
"Talks at the Yanan Forum on Literature and Art,"
established broad and long-lasting guidelines for art
production. Mao's core belief was that art should serve
the people. For this to happen, artists must understand
the people and create art relevant to their lives. Mao
believed that, eventually, the masses would be
educated to appreciate a higher level of art, but in the
meantime, to fabricate elitist art was self-serving.
These talks became central to much subsequent
debate on art through the Cultural Revolution. Since
Mao's death, direct political control of art has gradually
waned; still, the government continues to invoke a
paternalistic responsibility to protect "the people"
whenever it wishes to re-exert control over art. As
recently as the spring of 2001, for example, the
Ministry of Culture issued a circular deploring works of
art that "disrupt social order, corrupt social values,
damage the collective physical and mental health of
the people, and have a harmful effect on society,"
affirming the need to "safeguard social order, purify the
cultural environment, and eliminate cultural refuse," and
stating that "all units involved in artistic creation,
education or research must increase the propagation
and teaching of Marxist aesthetic theory and Party
policy on arts and literature [and] increase the control

on creative, educational and research activities."[2] The nervousness evoked in the arts community by that particular circular has since evaporated, but the prospect of such directives has not disappeared.

The long-term connection between art and politics has become so ingrained an aspect of twentieth-century Chinese art that it must be taken into consideration even for the most recent contemporary work and is particularly true of art created by those who came of age during the Cultural Revolution and the years immediately following. This is not to say that all post–Cultural Revolution art has had politics or social concerns at its heart; however, as a group, it is only today's younger artists who have broken free of the mind-set.

## Cultural Revolution

In 1966, in a move to reaffirm his control over China, Mao Zedong urged all students to rebel. Thus began the Great Proletarian Cultural Revolution, which triggered a national descent into chaos. In the name of ongoing revolution, the students, calling themselves Red Guards, set about destroying all vestiges of bourgeois culture, intending, according to their Machiavellian manifesto, to "turn the old world upside-down and smash it to pieces!"[3] They interpreted their mandate in broad terms (fig. 4), with wide-ranging results, their excesses including such ingenuously enthusiastic actions as switching the colors of stop lights so that red—representing the Chinese Communist Party—signaled Go instead of Stop, and changing street names to reflect revolutionary values. The drive to destroy the "Four Olds" (old thought, old customs, old culture, and old morals) also entailed the mass destruction of books and art, including untold quantities of cultural artifacts from the pre–Communist era. But the Red Guards did not confine their fervor for destruction to objects: with equal zeal they destroyed people who represented bourgeois values. They persecuted teachers and other authority figures, forcing them to carry out demeaning and debilitating physical labor, often beating or imprisoning them, and sometimes directly causing their deaths or driving them to suicide. The number of people who died in the excesses of the Cultural Revolution is not known, but may amount to more than one million. The most extreme period of the Cultural Revolution ended in April 1969, but the general climate of destruction and persecution continued until Mao's death in 1976.

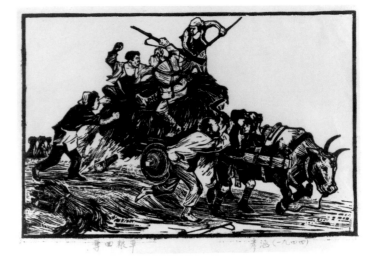

Fig. 2. Yan Han, *Taking Back the Fodder*, 1944. Woodblock print on paper, 19.5 x 27.4 cm. From the portfolio *Selected Woodcut Prints from the Lu Xun Art Academy*. Collection of the Iris & B. Gerald Cantor Center for Visual Arts, Stanford University, given in memory of Dr. Leo Eloesser by Joyce Campbell, 2002.145.9.

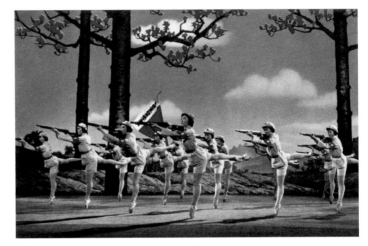

Fig. 3. *Red Detachment of Women*: "Fighters of the women's company perform a spirited rifle drill." Postcard.

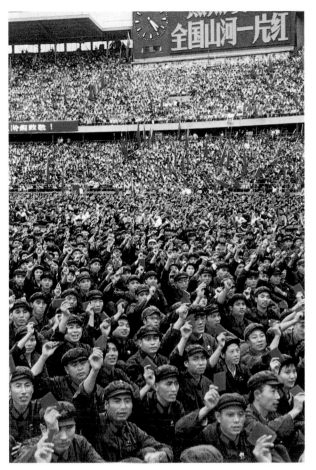

Fig. 4. "A Beijing Rally, 100,000 strong, rejoice over the Founding of Revolutionary Committees in All Provinces, Municipalities, and Autonomous Regions of China (with the Exception of Taiwan Province)." *China Reconstructs*, December 1968, back cover.

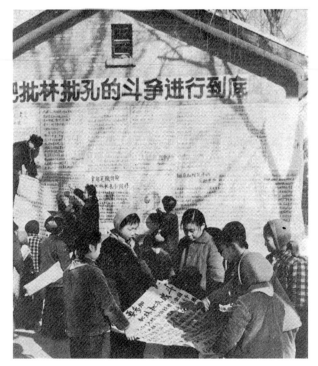

Fig. 5. "Teachers and pupils put up posters criticizing Lin Biao and Confucius." *China Reconstructs*, August 1974, p. 3.

Isolating itself from the world, China conducted the Cultural Revolution behind closed doors. Little information about international contemporary art was available in China during that time. Traditional brush and ink painting, unless deployed in the service of revolutionary subject matter such as hydroelectric dams or Mao visiting with the people, became unacceptable, as was all art for art's sake. With the closure of art academies and art and architecture journals, the infrastructure of the established art world was demolished. The Red Guards wrote political texts as "big character" posters in public spaces (fig. 5) and encouraged others to do the same, so that wherever they went people were submerged in a sea of exhortatory text. A significant proportion of art was devoted to the adulation of Mao: his image appeared everywhere, in mass-produced posters (fig. 6), busts, and statues.[4] In addition, artists produced highly politicized paintings and developed works in the new genres of revolutionary ballet and revolutionary opera. Pushing the precepts outlined in Mao's "Talks at the Yanan Forum" to extremes, art created by workers, peasants, and soldiers—the masses—as well as by the revolutionary students, was favored. That of trained artists was pronounced acceptable only if it served the masses by conforming to revolutionary principles of art production. Painters pushed the emotionalism of Socialist Realism to the extremes of propaganda, focusing on the human figure, particularly that of the ideal revolutionary worker/peasant/soldier (fig. 7). The visual arts became programmatically unified, until the same type figures with the same limited range of expressions and heroic gestures appeared in paintings, staged news photographs, posters, woodcuts, films, and model books (that is, image source books for artists). The government mobilized visual propaganda to the extent that, in one instance (fig. 8), publishing houses printed over nine hundred million poster reproductions of a single painting of Mao in support of an ideological campaign.[5] Not only was the visual landscape unified, but also people of all ages and walks of life contributed to propaganda production. Factories developed after-work arts programs and school children wrote "blackboard newspapers," political messages on public blackboards.[6]

### After the Cultural Revolution
When the Cultural Revolution ended, students eagerly sought entry to the newly reopened art

academies. With no art market and no private business, the only way to make a living as an artist was to earn a degree and then take a position in a government-run publishing house, school, or other suitable entity, hence the premium placed on art-school degrees. Because the teachers, coming from an older generation, were versed in Socialist Realism, their students in the late 1970s and 1980s all gained a thorough training in drawing from life and creating images of great verisimilitude and, often, emotionalism. Such training afforded students powerful tools, but for young artists seeking to develop a means of personal expression, the path was not obvious. Those who did find a new direction —the first wave of innovative post–Cultural Revolution artists—initiated two trends of lasting importance: figure painters rethinking the genre and artists working outside the official art system.

Probably the most famous painting from the decade after Mao's death, *Father* (fig. 9), painted in 1980 by Luo Zhongli (b. 1950), exemplifies the reexamination of figure painting, a trend that began with the abandonment of the robust youthful heroes who had dominated the genre during the Cultural Revolution. In the late 1970s Luo, who had participated in the Cultural Revolution as a Red Guard, was admitted to the reopened Sichuan Academy of Fine Art. There, fascinated by a magazine reproduction of a painting by Chuck Close, he decided to experiment with photorealism. *Father* represents a man whom Luo had met "on the eve of the Spring Festival five years before. [He was] a half-frozen peasant, watching the latrine that contained the manure which was to fertilize [his] meager plot."[7] Impressed by the peasant's stolid acceptance of his lot in life, Luo determined to paint him using the heroic scale generally reserved for iconic public portraits of Chairman Mao, notably the well-known portrait hanging over Tiananmen (the Gate of Heavenly Peace). Clinging to notions of the role of art in society, authorities insisted that Luo amend the painting by including a ballpoint pen behind the subject's ear to show that the man was an educated agricultural hero, not simply an old peasant.[8] The addition of the politically charged pen allowed the otherwise subversive painting to win first prize in the Second Exhibition of Young Artists' Works and thus to reach an enormous audience through widespread publication.

Fig 7 "Heighten our vigilance, defend the motherland! Be ready at all times to destroy the enemy intruders!" 1969. Poster, 280 x 390 cm.

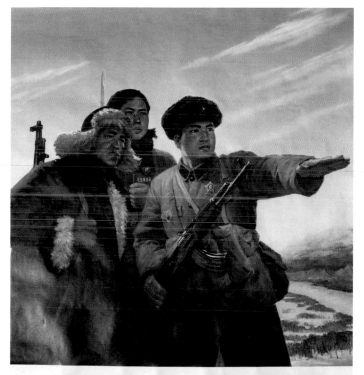

提高警惕．保卫祖国！
随时准备歼灭入侵之敌！

g. 6. Standard portrait of Chairman Mao.
*hinese Literature*, no. 1, 1977, frontispiece.

The most prominent group working outside the system, the Stars, smashed conventions in a deliberately confrontational manner. In 1978, young idealists in Beijing had been allowed to paste posters calling for democracy on what became known as Democracy Wall. Then, in an abrupt turnaround, by March 1979 the government had banned "big character" posters and publications opposing socialism, and sentenced a leader of the democracy movement, Wei Jingsheng, to fifteen years in prison. Only six months later the twenty-three artists in the Stars group audaciously hung an exhibition of their works on a fence outside China's most prestigious gallery, the National Art Gallery of China in Beijing (fig. 10). None of the Stars held official positions as artists, but many had family ties to the intelligentsia or officialdom, affording them a sophisticated appreciation of the mechanisms of power in China. The quality of the exhibited art was uneven, but the show was notable for embracing two taboo subjects—nudity and politics—and for exploring new modes such as collage. It also succeeded in demonstrating that an official art position was not an absolute prerequisite to being an artist. Before the Stars exhibition, a few art shows had already marked the beginnings of dissident art in China, but none was as politically and conceptually savvy. The group's sense of timing, in particular, contributed significantly to the outcome of the exhibition. Because the artists dared to hang their exhibition in public, next to the most important gallery in China, the police could not avoid confronting them over the use of public space. On the day after the opening, the police tried to arrest the artists but backed down when the group insisted on the guarantee of artistic freedom afforded by the Chinese constitution. But, before the show could be set up on the third day, the police effectively closed it down simply by preventing the artists from accessing either the exhibition site or the site where their works had been stored overnight. In addition, they supposedly sent minor criminals to harass the artists.[9] Then the Stars, carrying a sign reading We Demand Artistic Freedom, held a protest march on National Day; foreign reporters who were in Beijing to cover the National Day celebrations found the dissident artists much more newsworthy. A year later, the National Art Gallery gave the Stars two rooms in which to hold a second exhibition, which was attended by forty thousand visitors. Among the most notable works in this second exhibition was a sculpture of Mao Zedong, *Idol* (1978; fig. 11), by

Fig. 8. "Workers of Beijing Foreign Languages Printing Press performed songs and dances composed by themselves after they heard the happy news that they had been given the glorious task of printing the oil painting *Chairman Mao Goes to Anyuan.*" *China Reconstructs*, October 1968, back cover.

Fig. 9. Luo Zhongli, *Father*, 1980. Oil on canvas, 215 x 150 cm. National Art Gallery of China, Beijing.

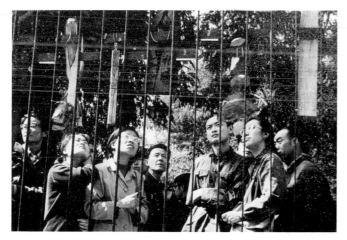

Fig. 10. The first Stars exhibition, Beijing, 1979.

Wang Keping (b. 1949), who dared to portray the previously iconicized leader as a jowly Buddha-like character turning a blind eye to the troubles surrounding him. As artists, the Stars had effectively used their self-created platform to make a political point and to push for more freedom within the system.

### The '85 Art Movement and the *China/Avant-Garde* Exhibition

Deng Xiaoping (1904–1997) came to power in 1978 and remained China's leader until 1997. Under Deng, "no one in the upper reaches of government really cared what artists were doing. . . . Rather than setting up cultural models, Deng's art policy seems to have consisted only of the occasional and unpredictable crackdown. . . . Artists who chose to experiment might show whatever the party did not specifically ban."[10] Swings in political pressure on the arts continued during the early 1980s, but the general trend was toward a relaxation of government control. A parallel tolerance toward imported texts allowed an influx of information about Western art and philosophy, which arrived in an undifferentiated rush. Suddenly artists discovered a myriad approaches to art, including Impressionism, Pop, Dada, and Abstract Expressionism. The combination of relative freedom with a surfeit of new ideas during the later 1980s provided the impetus for over 2,000 avant-garde artists to participate in more than 80 unofficial art groups and over 150 exhibitions and meetings.[11]

The scholar and curator Gao Minglu, who coined the term "'85 Art Movement," divides the major avant-garde art trends included in this movement into two, the humanist and the conceptualist.[12] All the artists involved were idealists searching to alter society, no doubt in reaction to the disorder they had experienced during the Cultural Revolution and its aftermath. The humanists took two approaches, one seeking a new, more rational order, the other seeking to realign people with their—overly suppressed—emotions. Wang Guangyi (b. 1956), a leading rationalist artist, created an extraordinary set of paintings, *Mao Zedong—Black Grid* (1988; fig. 12), rendering Mao in emotionally dampened shades of gray, with an overlying black grid intended to suggest the need for rational analysis, but also resembling the bars of a cage.[13] Eight years earlier Luo Zhongli had employed some subtlety in exploiting the format of the standard Mao portrait to comment on the position

of the peasant in Chinese society; Wang Guangyi abandoned subtlety entirely in his dramatic call for a new order.

The conceptualists, meanwhile, were intent on subversion. Many found inspiration in Dada, meshing that with an interest in Chan philosophy (known in Japan as Zen). Huang Yong Ping (b. 1954), the founder of the group Xiamen Dada, attacked the institution of art in multiple ways. Attempting to void the concept of authorship of the work of art, he constructed, between 1985 and 1988, a series of roulette wheels to provide arbitrary directions for creating his so-called Non-Expressionist paintings. Denying the value of the work of art as a lasting historical object, the Xiamen Dada group burned all the works included in its 1986 exhibition in Xiamen. Perhaps inevitably, if the work of art is to be voided, so, too, should attempts to understand art. Accordingly, Huang Yong Ping placed two leading texts on Chinese art history and modern Western art in a washing machine for two minutes, the result being an unprepossessing pulp. He exhibited the pulped texts as *"The History of Chinese Art" and "A Short History of Modern Art" after Two Minutes in a Washing Machine, December 1987* (fig. 13).

Text provided a focus for several other important conceptualists of this period, including Wenda Gu (b. 1955), Wu Shanzhuan (b. 1960), Xu Bing (b. 1955), and Zhang Peili (b. 1957). The Cultural Revolution had imparted a profound sense of the unreliability of the

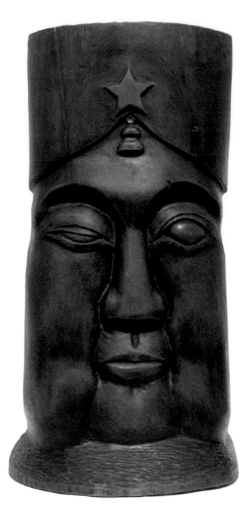

Fig. 11. Wang Keping, *Idol*, 1978. Wood, 67 cm high.

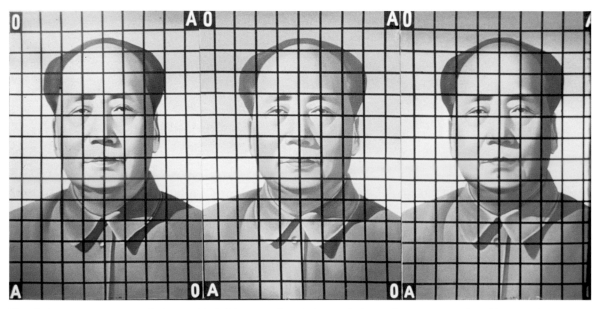

Fig. 12. Wang Guangyi, *Mao Zedong—Black Grid*, 1988. Set of three paintings, oil on canvas, 150 x 120 cm each.

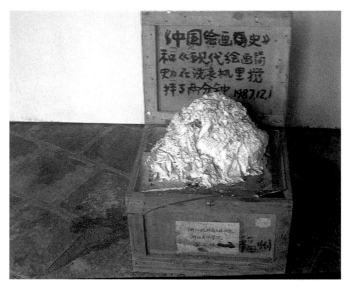

Fig. 13. Huang Yong Ping, *"The History of Chinese Art"and "A Short History of Modern Art" after Two Minutes in a Washing Machine, December 1987*, 1993 version (1987 version destroyed). Pulped paper, wood, and glass; approx. 80 x 50 x 50 cm.

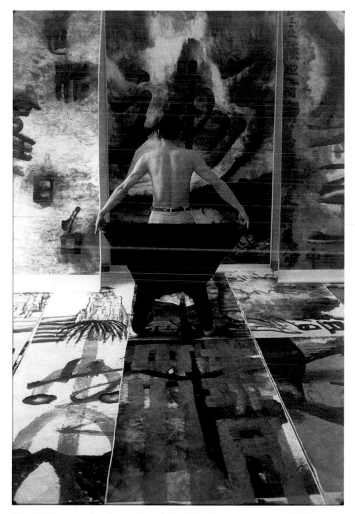

Fig. 14. Wenda Gu, *Speechless #1*, 1985. Performance, with ink painting installation, Zhejiang Academy of Fine Arts, Hangzhou.

written word to these artists, all of whom had inevitably been surrounded by propaganda texts when they were young. As a youth, Wenda Gu had written "big character" propaganda posters, and Xu Bing had filled school blackboards with politically charged texts.By the mid-1980s Gu had developed several approaches to negating the validity of the written word: he wrote poster-sized characters devoid of context or with Xs voiding them; he created monumental paintings each incorporating a single Chinese character made by altering or combining existing characters; and he performed wordless "speeches" against a backdrop of his paintings. *Speechless #1* (1985; fig. 14) is an example of a nonsensical, wordless speech performed in front of and atop paintings that include miswritten, altered, or recombined characters. The fact that Gu is a masterful calligrapher by traditional standards added shock value to his works, which were criticized as vulgar and pornographic. Seeking a less censorious environment, he moved to the United States in 1987.

That same year, Xu Bing started working on an installation that was to exert a profound effect on the Chinese art world. So intent was he on voiding both the content of the written word and the general authority of textual materials that he devoted a year to creating the first version of this work, beginning by developing a set of twelve hundred and fifty invented Chinese characters. Next he carved the spurious characters into woodblocks, which he used to typeset and print a set of four books bound with traditional paper covers and string binding. Aiming for perfect execution, he then redesigned and remade the books entirely. At first glance, the finished set, the *Book from the Sky* (1987–1991; fig. 15), looks like an important set of the classics. For an exhibition at the National Art Gallery in 1988, Xu Bing spread the first version of the books on the floor, hung scrolls printed with the same characters from the ceiling, and covered the wall with similarly printed panels. Visitors to the exhibition (fig. 16) found the installation to be an overwhelming experience, presenting a familiar face and yet utterly incomprehensible. Some felt that it negated the value of Chinese culture; others, especially members of avant-garde art circles, saw it as confirmation that contemporary Chinese art was finding a new, powerful direction.[14]

On 5 February 1989 the *China/Avant-Garde* exhibition (also known as the *Contemporary Chinese Art*

*Exhibition*), curated by Gao Minglu and Li Xianting, opened at the National Art Gallery of China. Several years in the planning, the exhibition brought together important works by the major avant-garde artists of the 1980s, including *Mao Zedong—Black Grid* by Wang Guangyi and *"The History of Chinese Art"* and *"A Short History of Modern Art" after Two Minutes in a Washing Machine, December 1987* by Huang Yong Ping, a text-based installation by Gu Wenda, and *Book from the Sky* by Xu Bing. To be permitted to hold such an exhibition in the nation's most prestigious art gallery seemed to bode well for the future of the Chinese avant-garde.

During the mid-1980s the genre of performance art had been developing apace and many artists arrived at the opening day of the *China/Avant-Garde* exhibition with performances planned to accompany it. Wu Shanzhuan brought live shrimp to sell as a protest against an art system that pits the artist against the selective judgment of art-world authorities; Li Shan (b. 1944) offered to wash feet in a basin painted with the visage of Ronald Reagan; others sat atop an egg-filled nest or distributed condoms. The exhibition itself was officially sanctioned; the performance art was not. Plainclothes police closed down the shrimp stall and called a halt to other activities. Trouble erupted when pistol shots resounded through the gallery: Xiao Lu (b. 1962) had fired a pistol at her installation, *Dialog* (1989). This became known as the *Pistol Shot Event* (fig. 17). Police closed the exhibition for five days and arrested Xiao Lu and her boyfriend, Tang Song (b. 1962), who had taken charge of the gun following the shots.[15] Relying on the risky but carefully calculated gamble that their family status would protect them, the artists had planned the action as an exposé of the uneven application of Chinese law. In this they were successful: children of highly placed officials, they were both released from jail after a mere three days.[16]

Two weeks later the *China/Avant-Garde* exhibition was closed permanently as a result of bomb threats. Those who had organized or supported the exhibition were fined or banned from participating in art activities; curators were

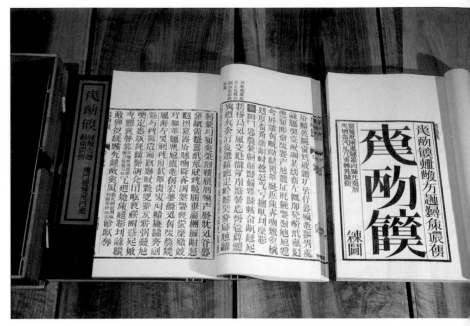

Fig. 15. Xu Bing, *Book from the Sky*, 1987-1991. Set of woodblock-printed books, second version, detail. Collection of the artist.

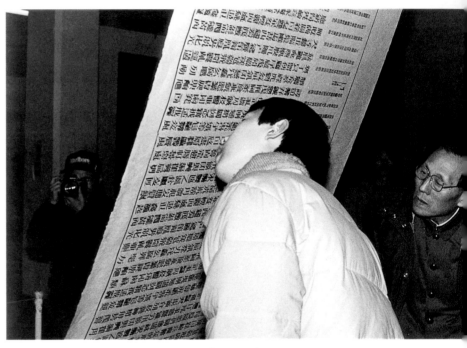

Fig. 16. Viewer examining Xu Bing's *Book from the Sky*. Installation, woodblock-printed books and scrolls, National Art Gallery of China, Beijing, 1988.

forbidden to work with galleries for two years; and the magazine *Fine Arts in China*, an important arena for the discussion of avant-garde issues in art, was closed down for two years and did not ever reopen. The Ministry of Culture stated that, in future, only vetted art could be exhibited, thus eliminating performance art, happenings, and similar spontaneous events.[17]

The naive faith in a rosy future for avant-garde art that had flourished two weeks earlier was dashed. Four months later, during the huge demonstrations for democracy that went on for a month in Tiananmen Square, a group of students from the Central Academy of Fine Arts constructed the imposing Goddess of Democracy statue, which was funded by the Federation of Beijing University Students and placed opposite the portrait of Chairman Mao overlooking Tiananmen Square. The statue was destroyed during the massacre of demonstrators by government troops on June 4.

### After Tiananmen: Despair, Cynicism, and Pop

With their youthful idealism crushed, the artists retreated. Of those mentioned above, Tang Song and Xiao Lu left China for Australia, Xu Bing went to the United States, and Wu Shanzhuan and Huang Yong Ping emigrated to Europe. Many other Chinese artists and intellectuals chose to emigrate at this time. Within China, several new artistic directions became apparent. Inevitably, many artists expressed their sense of loss or feelings of oppression through their art. Others became cynical or sardonic, their paintings known by the rubrics Cynical Realism and Political Pop. Still others simply focused on their work, knowing there would be scant opportunity to exhibit publicly. Certainly, they all abandoned the notion that they could find a place within the official Chinese art system.

The sculptor Sui Jianguo (b. 1956), with *Earthly Force* (1991; fig. 18), a series of small boulders enmeshed in iron bars, produced an extraordinarily effective visual metaphor for emotional oppression. Other artists articulated their sense of helplessness and tragedy much more directly through the representation, almost unprecedented in Chinese art, of the tormented, dismembered, or hospitalized body. The subject of the body as locus for physical pain was anathema to both traditional Chinese painting and to official, state-sanctioned art. Socialism had glorified the body through the figure of the ideal revolutionary, who was invariably healthy, strong, and

Fig. 17. Xiao Lu, *Pistol Shot Event*. Performance with her installation piece, *Dialog*, in the *China/Avant-Garde* exhibition, National Art Gallery of China, Beijing, 1989.

Fig. 18. Sui Jianguo, *Earthly Force*, 1991. Iron and granite, each approx. 60 x 70 x 50 cm.

optimistically zealous under even the most adverse circumstances. In a move diametrically opposed to such glorification of the body, the painter Zeng Fanzhi (b. 1964) depicted anguished figures as so much meat, sometimes stretched inert on hospital beds and subject to the doctors' dispassionate manipulation (fig. 19). With varying degrees of obfuscation, others—notably Zhang Xiaogang (b. 1958)—used the body as a metaphor for the soul or the self, a self that events had rendered passive and manipulated mercilessly. Lü Shengzhong (b.1952) began to create installations of papercut "little red figures," the folk-art motif serving its traditional function as a metaphor for the soul of the dead. The installation of thousands of little red figures in his small studio, *Calling Home the Soul of the Dead Hall* (fig. 20), which was created in the year following the Tiananmen massacres, was rendered particularly poignant by its timing.

As an alternative to despair, cynicism was a reasonable reaction to the events of 1989. As the Cynical Realist painter Fang Lijun (b. 1963) stated, "We prefer to be called the lost, bored, crises-ridden, bewildered hoodlums, but we will not be cheated again. Don't think about educating us with old methods, for we shall put ten thousand question marks across all dogmas, then negate them and toss them on the trash heap. . . . Only a jackass would fall into a trap after having fallen into it a hundred times."[18] *New Generation* (1990; fig. 21), by the prominent Cynical Realist Liu Wei (b. 1965), suggests that Chairman Mao may not have left a positive legacy. Mao, depicted in the poster that fills the background, is disheveled and disreputable, and the two very young children in front of him are sadly warped. Yet the overall effect is strangely warm and comical. Icons of the revolution have been unmasked, and the true feelings of ordinary people revealed.

Like the Cynical Realists, the Political Pop artists twisted their rigorous academic art training to convey a new message, defusing potent political imagery with an American Pop sensibility, and criticizing the current condition of Chinese culture. A major Political Pop project was the visual deconstruction of Mao, undertaken by Yu Youhan (b. 1943; fig. 22), Li Shan, Liu Dahong (b. 1962), Zhang Hongtu (b. 1943; figs. 92, 93, 94), and others. This desecration coincided with the Mao Craze, a popular movement that accorded Mao the kind of fond fervor reserved for Elvis in the West.[19] Both approaches brought Mao down from his

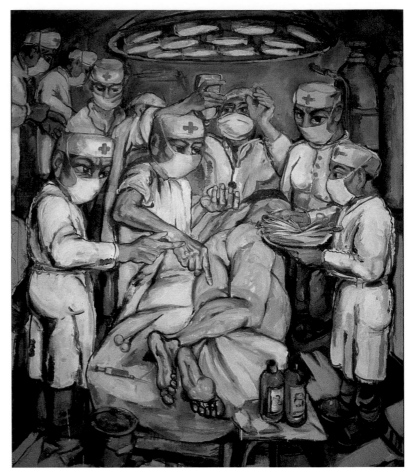

Fig. 19. Zeng Fanzhi, *Hospital Triptych*, 1991 (detail of center panel). Oil on canvas, three panels, each 180 x 150 cm.

Fig. 20. Lü Shengzhong, *Calling Home the Soul of the Dead Hall*, 1990. Installation, papercuts.

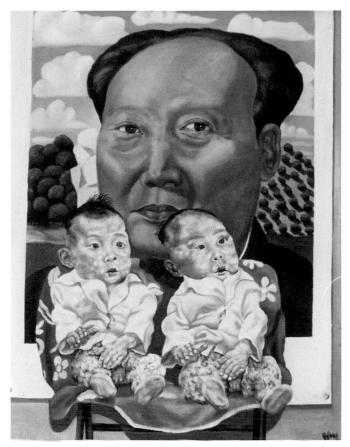

Fig. 21. Liu Wei, *The New Generation*, 1990. Oil on canvas, 104 x 85 cm. Francesca Dal Lago Collection.

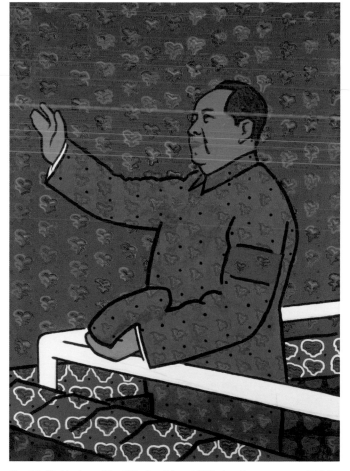

Fig. 22. Yu Youhan, *The Waving Mao*, 1992. Acrylic on canvas, 165.5 x 118 cm. Collection of the Guy & Myriam Ullens Foundation, Brussels.

pedestal and exposed the relationship that had existed between him and the Chinese people as bizarre. Certainly, the need to reevaluate his hold on the collective psyche was widely felt after the events of 1989 destroyed any faith in political ideals.[20] Consumerism blossomed in the early 1990s, as Deng Xiaoping's economic reforms flourished in the ideological void. In reaction to that, Wang Guangyi began his long-lived *Great Criticism* series, combining propaganda poster figures with prominent consumer brand names such as Coca-Cola (fig. 23), Canon, and Marlboro. At a time when Chinese consumers were rushing to buy foreign consumer goods, he was pointedly equating socialist propaganda with advertising.

A small minority discovered a voice with no connection to political or sociological events. Cai Jin (b. 1965), for example, began her *Beauty Banana* series in 1991, and has since based all her paintings (fig. 24) on a set of photographs of dried Beauty banana (*meirenjiao*) plants she took in 1990. She does seem to have been obsessively drawn to her chosen motif, but other artists working with abstraction, such as Ding Yi (b. 1963), who began his *Appearance of Crosses* series (fig. 25) as early 1988, may originally have sought abstraction as an alternative to seemingly unavoidable political or sociological subjects.

### Art after 1989

In 1993 a blockbuster exhibition, *China's New Art, Post-1989*, opened in Hong Kong.[21] Focusing on the major artists from the *China/Avant-Garde* show, the exhibition was organized by Johnson Chang (who is also known as Chang Tsong-zung), whose gallery, Hanart T Z Gallery, offered Political Pop and Cynical Realist painters a market, first in Hong Kong, and then overseas. Meanwhile, the giants among the conceptualists who had moved overseas, among them Xu Bing, Huang Yong Ping, Wenda Gu, Chen Zhen (1955–2000), and Cai Guo-Qiang (b. 1957), were on their way to international stardom.

For many who remained in China, however, the situation was difficult. Painters and printmakers could at least complete their works in the studio, show them to friends and colleagues when they had the opportunity, and hope for sales to foreign collectors. For conceptual and performance artists, installations and performances were necessarily fleeting, had no market, and often required large, adaptable spaces

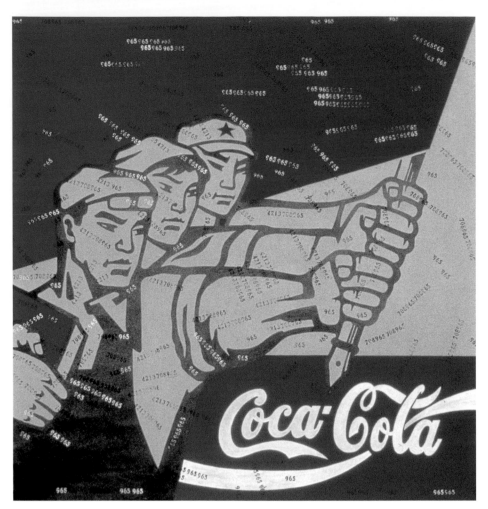

Fig. 23. Wang Guangyi, *Great Criticism—Coca-Cola*, 1990–1994. Oil on canvas, 200 x 200 cm.

Fig. 24. Cai Jin, *Beauty Banana No. 48*, 1994. Oil on canvas, 200 x 190 cm.

Fig. 25. Ding Yi, *Appearance of Crosses 92-1*, 1992. Oil on canvas, 140 x 160 cm.

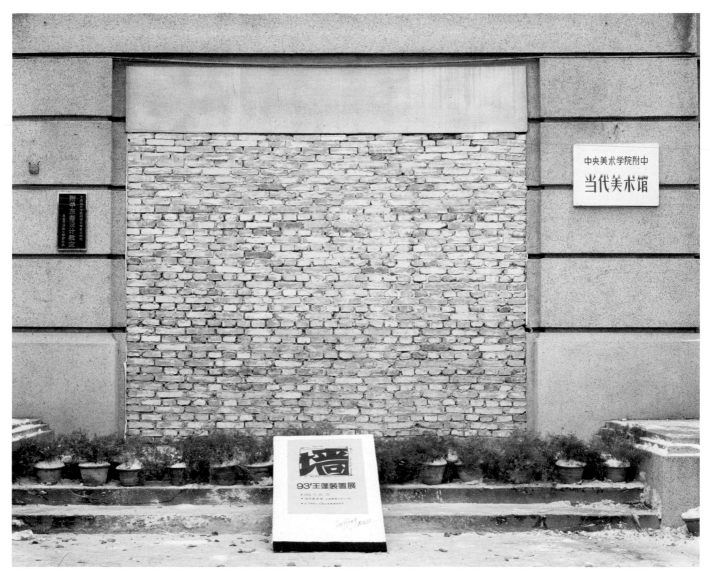

Fig. 26. Wang Peng, *The Wall*, 1993. Bricks.

that were simply not available. In the first half of the
1990s few avant-garde exhibitions were realized and,
of those that were, many were forced to close. Wu
Hung noted that during that time six exhibitions were
mounted in 1990, eight in 1991, eleven in 1992, nine in
1993, ten in 1994, and nine in 1995—very few com-
pared to the numbers obtaining in the late 1980s.[22]
Wang Peng (b. 1964) protested the situation in 1993
by walling off the entrance to the Contemporary Art
Gallery in Beijing (fig. 26) not long after authorities
had closed down two other exhibitions there.
Scheduled to run for just three days, Wang Peng's
solo show, *The Wall*, was ordered removed on the
second day.[23]

The middle years of the 1990s were important for
establishing modes of art that were not encouraged
in the art academies, that is, modes of art other than
painting, printmaking, and sculpture. The near
impossibility of exhibiting in a gallery necessitated the
creative search for alternatives. In Beijing Lin
Tianmiao (b. 1961) and Wang Gongxin (b. 1960), Song
Dong (b. 1966) and Yin Xiuzhen (b. 1963), and others,
held exhibitions of their installations in their homes.
The Guangzhou group, Big Tail Elephants (Chen
Shaoxiong [b. 1962], Liang Juhui [b. 1959], Lin Yilin [b.
1964], and Xu Tan [b. 1957]), installed their works in
an empty house (*No Room* exhibition, 1994; fig. 27).
Even more fleeting than these unofficial exhibitions
were performances done for small invited audiences.
Xu Bing's *Case Study of Transference* (1994; see figs.
87, 88), for example, was witnessed by a small group
of people informed of the event only a short time
before it occurred. Other alternatives included
organizing art activities that would not result in
exhibitions, for example calling on artists to create
works around a given theme, works that were to be
published but not exhibited together (for example, *45
Degrees as a Reason*, 1995), and privately publishing
books to disseminate new ideas about art (such as,
*Black Cover Book*, 1994, *White Cover Book*, 1995,
and *Grey Cover Book*, 1997, produced under the
direction of Ai Weiwei [b. 1957]).

Disengagement from the official art system not only
spurred artists to search for alternative venues, but
also led them to turn to more personal subjects. The
leading performance artists Ma Liuming (b. 1969) and
Zhang Huan (b. 1965) established their careers while
living in deplorable conditions in Beijing's East Village,
a colony of artists who had moved to Beijing without

Fig. 27. Xu Tan, *The Alterations and Extension
Project for 14 Sanyu Road in Guangzhou*, 1994.
Installation, *No Room* exhibition, Guangzhou.

Fig. 28. Zhang Huan, *12 Square Meters*,
1994. Performance.

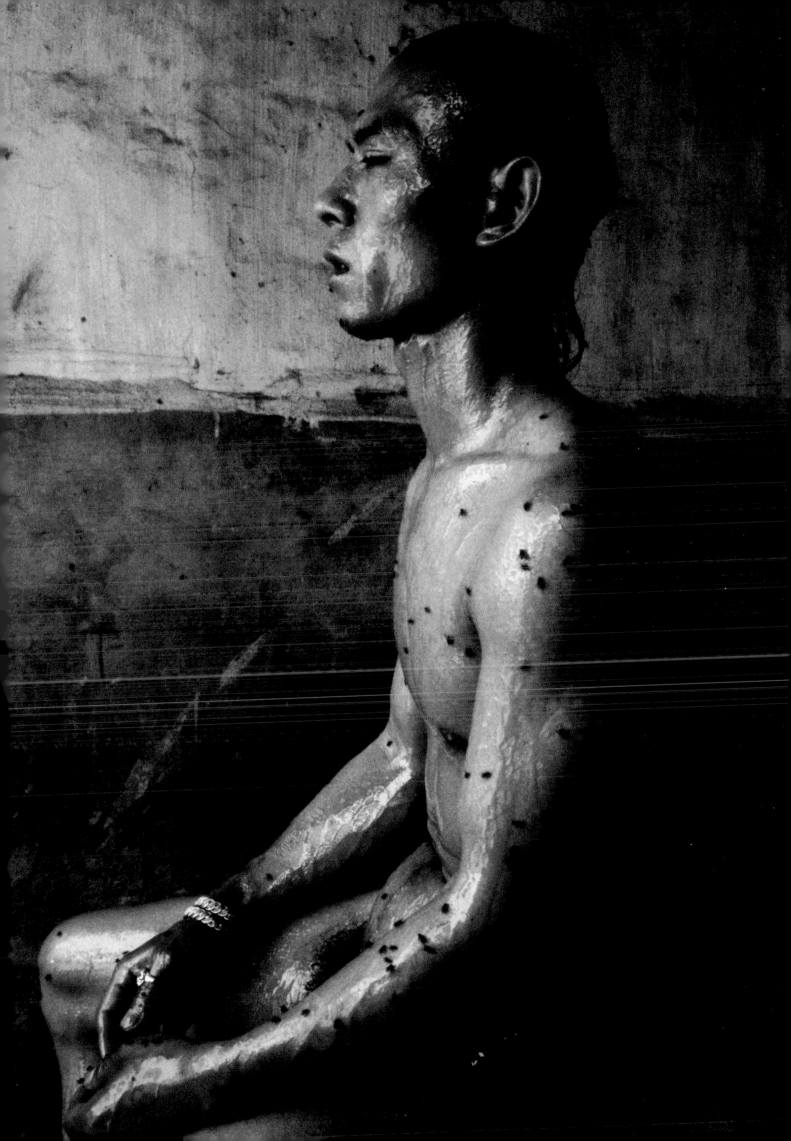

residency permits, and thus could find only the most decrepit housing, located near a garbage dump. Their early performances reflect their circumstances, and contrast with the rush to wealth and the rampant consumerism that was blossoming in artistic circles as much as in the wider population. A stark statement of the hardship they endured, Zhang Huan's performance, *12 Square Meters* (1994), took place in an East Village public toilet, where the artist sat unmoving and covered with flies for an hour (fig. 28).

The photographers who documented the East Village performances, chief among them Rong Rong (b.1968), who photographed *12 Square Meters*, and Xing Danwen (b. 1967), went on to establish photography as an important medium for Chinese artists. The 1990s also witnessed an expansion of available media into high-tech, thanks to such pioneering artists as Zhang Peili with video, Feng Mengbo (b. 1966) with computer art, Wang Gongxin with computer-edited video (fig.29), and Shi Yong (b. 1963) with online art.

The East Village in Beijing has long since been demolished and bulldozers and cranes have razed and rebuilt vast stretches of the city's center, replacing old neighborhoods with towering business centers, hotels, and characterless apartment complexes. China's other cities have endured similar transformations as a corollary to rapid economic growth. The transformation of the urban environment has galvanized many artists, including Song Dong, Lin Yilin, Yin Xiuzhen, and Zhan Wang (b. 1962).[24] Lin Yilin focused attention on the unquestioning acceptance of the burgeoning city's rushing speed by disrupting it: for his intervention, *Safely Crossing Linhe Street* (1995), he gradually moved a wall, brick by brick, across a busy intersection in Guangzhou in the middle of the day (fig. 30).

Other subjects that have absorbed artists are the crass commercialism and thirst for consumer goods that have arisen in tandem with economic growth, the anonymity of life in the city, and feminist issues, subjects that were not generally thought of in terms of art. Lin Tianmiao's *Bound and Unbound 1995–97*, an installation of household objects laboriously wrapped with cotton thread (fig. 31), makes plain the repetitive and time-consuming nature of so-called women's work. The artist did not intend this as a feminist statement, yet the result has feminist implications.[25]

Fig. 29. Wang Gongxin, *The Sky of Brooklyn: Digging a Hole in Beijing*, 1995. Video installation.

Fig. 30. Lin Yilin, *Safely Crossing Linhe Street*, 1995. Ninety-minute performance.

Fig. 31. Lin Tianmiao, *Bound Unbound 1995–97*, 1995–1997.
Installation, with utensils, cotton thread.

## Conclusion

All told, the themes of post-1989 avant-garde art,
unlike art during the Cultural Revolution and earlier,
were not directed by the government but,
nevertheless, reveal an overriding engagement with
social issues. Discussion of the art of this period is
frequently framed in terms of sociological matters
such as the residual effects of the Cultural
Revolution, urbanization, commercialism, economic
disparities, and alienation. The dramatic changes
experienced by the artists ensured these would be
gripping issues. Works expressing other concerns
have, as a result, been overshadowed. Working
outside the prevailing paradigm, artists such as Chen
Haiyan (b. 1955) and Sun Liang (b. 1957) produce
Surrealist prints and paintings; Shen Fan (b. 1952),
Ding Yi, Lu Qing (b. 1964), and others paint
abstractions; Geng Jianyi (b. 1962), Zhang Peili, and
Yang Jiechang (b. 1956) have pushed the limits of
photography, video, and ink painting. Even so, for
many of these midcareer artists, politics and social
changes have also been of interest. Now, a younger
generation born into an already changed China is
finding sociological issues less compelling. Younger
artists have, among other things, posed new
questions about art, experimented with shocking

media, and ruminated on romance. The situation for exhibiting art has changed completely, too. Government-owned galleries are joined by more and more privately held galleries each year. Avant-garde artists from China and elsewhere can show cutting-edge works in both kinds of venues, so long as they avoid the still taboo subjects of sex and politics.[26] Only when artists showing in private galleries cross the line too blatantly does the government take action. (It was young artists experimenting with the shock media of human corpses and animal bodies that provoked the circular cited above.) Chinese artists now participate actively in the international art arena. The best known spend much of their time traveling from exhibition to exhibition, a practice that Song Dong sardonically terms "art tourism." Wang Qingsong (b. 1965) has even spoofed the phenomenon in his staged photograph, *Art Express* (2002; fig. 32), in which tourists board the bus to "the world," with stops at major international exhibitions.

Fig. 32. Wang Qingsong, *Art Express*, 2002. Photograph, 120 x 200 cm.

## Notes

Where notes are abbreviated, see Selected Bibliography for the full citation.

1. In 1971, years before formal diplomatic relations were established between the two governments in 1979, the American Ping-Pong team was invited to China. This kind of low-level exchange became known as Ping-Pong diplomacy.
2. Translation by Robert Bernell.
3. Wang Mingxian and Yan Shanchun, eds., *Xin Zhongguo*, 2.
4. For a discussion of the iconography of Mao Zedong during the Cultural Revolution, see Ellen Johnston Laing, *Winking Owl*, 65–70.
5. The oil painting was *Chairman Mao Goes to Anyuan* (c. 1967) by Liu Chunhua (b. 1944). The figure of nine hundred million is from Julia F. Andrews, *Painters and Politics*.
6. For a detailed account of changing tides in the art world during the Cultural Revolution, see Andrews, ibid., 314–76.
7. Pei Minxin, *China Daily* (30 June 1983), 5; as quoted by Joan Lebold Cohen, *New Chinese Painting*, 106.
8. For more on this painting, see Martina Köppel-Yang, *Semiotic Warfare*, 92–103.
9. For a description of the events surrounding the first Stars exhibition, see Andrews, *Painters and Politics*, 397–98.
10. Julia Andrews, "Black Cat White Cat," 22.
11. Gao Minglu, "Conceptual Art," 131
12. For Gao Minglu on the conceptualists, see Gao, ibid., 126–39 and illustrations, 218–22.
13. For more on this triptych, see Köppel-Yang, *Semiotic Warfare*, 152–61.
14. For more on the *Book from the Sky*, see Britta Erickson, *Words without Meaning*, 32–45.
15. Köppel-Yang, *Semiotic Warfare*, 175.
16. For more on the *Pistol Shot Event*, see Köppel-Yang, ibid., 174–80.
17. Geremie Barmé and Linda Jaivin, eds., "An Exhibition of Anarchy."
18. Jianying Zha, "The Whopper," 111.
19. For more on the Mao Craze, see Geremie Barmé, *Shades of Mao*.
20. For an analysis of the deconstruction of the Mao icon, see Francesca Dal Lago, "Personal Mao." See also Orville Schell, "Chairman Mao as Pop Art."
21. Valerie Doran et al., *China's New Art*.
22. Wu Hung, *Exhibiting Experimental Art*, 210–12.
23. For a close examination of government reactions to art after 1989, see John Clark, "Official Reactions to Modern Art."
24. For more on works on the urban environment by Song Dong, Yin Xiuzhen, and Zhan Wang, see Wu Hung, *Transience*, 108–13 and 120–26.
25. For more on women's art, see Britta Erickson, "Rise of a Feminist Spirit."
26. As an indicator of the continuing level of concern, the Ministry of Culture has indicated that Britney Spears's stage costumes will need to meet its approval prior to her tour of Beijing and Shanghai in 2005.

# CONTEMPORARY CHINESE ART VS. THE WEST

All in a day, tourists eager to see the world stroll past Mount Rushmore—a striking backdrop to the White House (fig. 33)—glance into Venice's Piazza San Marco, plunge down the Grand Canyon Log Flume Ride, shop on Paris Spring Shopping Plaza, and pose for photos next to Snow White, whose hair is exotically light brown rather than "as black as ebony," as specified in the fairy tale (fig. 34). Two-thirds of the attractions at Shenzhen's Window of the World theme park represent the West. Across the street from the park is the Crowne Plaza Venice hotel, seemingly decorated as a plush extension of Window of the World, and a few miles down the road is a copy of the Italian resort town of Portofino, translated into an upscale residential development.

Across the globe in Florida, visitors to the China Pavilion in World Showcase Land at Disney's Epcot Center can "explore China as never before. . . . Sweep from Beijing to Shanghai, from inner [sic] Mongolia to the Forbidden City, from the distant lands of the Hunan province to the Great Wall, discovering all the brilliant facets of this Land of Many Faces."[1] All of this is to be seen in the *Reflections of China* attraction (a 360-degree film) shown in a theater that you reach through the Temple of Heaven. The China Pavilion also includes copies of notable Chinese historical buildings, and offers demonstrations of noodle making, performances by the Dragon Legend Acrobats, and opportunities to purchase "authentic Chinese goods." Globalization may have brought Jackie Chan to Hollywood and put a Starbucks inside the Forbidden City in Beijing, but it has not penetrated deeply enough to put an end to the perception and consumption of one culture by another as exotic.

When Deng Xiaoping initiated his Open Door policy two and a half decades ago, curiosity ran high between China and the West. The fascination has long been mutual, with certain expectations on each side, including the assumption of difference. In the context of late twentieth-century shifts in power relationships, these expectations easily become highly charged, creating a tension that has also played out in the arts.

## Introductions

When information about Western art and philosophy began to flow into China in the late 1970s, young artists eagerly devoured imported images and texts as they sought alternatives to the limited artistic possibilities prescribed during the Cultural Revolution. Books on Western art were at first so rare that one art academy displayed a book on Impressionism in a glass case, a page turned each day. In 1979 the Zhejiang Academy of Fine Arts in Hangzhou was able to purchase a large collection of foreign books on art, resources that helped its students become among the most progressive in the country.[2] Exhibitions of Western art began to appear, too. *Paysages et paysans français 1820–1905* [French landscapes and peasants 1820–1905], the first exhibition of Western European art to be held in China, drew crowds in 1978.[3] After that, the content of imported exhibitions rapidly became more contemporary. In 1985 an exhibition in Beijing of the work of Robert Rauschenberg (b. 1925) "exploded like a bombshell in the Chinese art world, and, especially in the minds of the young generation, made at least one thing abundantly clear: the challenge of Western art was far greater than they could ever have imagined."[4]

For those artists who met the challenge of Western art and developed radical new styles, there were at first no employment or exhibition opportunities. The Chinese government did not encourage or support avant-garde art. In fact, it failed so miserably to understand the state of contemporary art and the workings of the international art world that it sent embroideries and papercuts to the Venice Biennale in 1980 and 1982, the only two years in which China has been represented officially at that most prestigious of international contemporary art exhibitions.[5] In such a vacuum, foreigners resident in China offered much-needed support for China's avant-garde artists by purchasing works of art, occasionally providing opportunities to exhibit, and

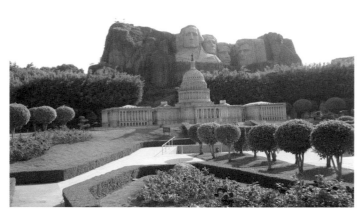

Fig. 33. Mount Rushmore and the White House, Window of the World theme park, Shenzhen.

Fig. 34. Tourists and Snow White, Window of the World theme park, Shenzhen.

acting as avenues of introduction to the outside world. Later, in the 1990s, foreigners established many of the first permanent spaces in China for exhibiting avant-garde art, including the first commercial galleries. An unusual public space, technically in German territory, was made available on the exterior of the wall of the German Consulate General in Shanghai (fig. 35).

It was Westerners outside China who first discovered contemporary Chinese avant-garde art as an expression of antiauthoritarianism. What the West has liked to distinguish as "dissident art," such as that produced by members of the Stars group, was an attention-grabber, showing the human face of a nation all too recently swathed in mystery. Geremie Barmé has pointed out that the Western press was primed to package Chinese artistic dissent, having already created a successful niche for stories on Eastern European and Soviet dissidents.[6] The French press was particularly enthralled by the tribulations of one of the Stars artists, Li Shuang (b. 1955), who was imprisoned for living with her fiancé, a French diplomat.

### Striding to the World

The collecting and exhibiting of Chinese avant-garde art in the West did not really take off until the early 1990s, after the *China/Avant-Garde* exhibition in 1989 had provided an opportunity for overseas curators to make contact with many artists.[7] Subsequently, *China's New Art, Post-89*, an exhibition organized in Hong Kong by Johnson Chang with the help of Li Xianting, a critic from Beijing, spread awareness as it traveled from Hong Kong to the United States, with variants appearing in Australia and the United Kingdom. Collectors quickly picked up on the pithy and bold Political Pop and Cynical Realism trends highlighted in *Post-89*, but were slower to grasp works with a less flashy surface. Cynical Realism and Political Pop brought with them the vicarious thrill of association with dissent (perceived if not necessarily genuine), and Political Pop paintings bore the added cachet of looking Chinese (see figs. 22, 23). Prominent representatives of these trends became quite wealthy.

Invitations to exhibit overseas came to be highly coveted. They brought not only recognition and the chance for sales, but also the opportunity to learn at first-hand about developments in international art. Participation in overseas exhibitions became an

essential mark of success; Hu Jieming's (b. 1957) sardonic video, *The Western "Journey to the West"* (fig. 36)—a play on a popular early Chinese novel of the same name—describes the rush to visit the West. The artist Zhou Tiehai (b. 1966) wrote about the need to establish a profile overseas: "While at a friend's studio, I met someone from the United States who said to me, 'Your name is not on my list.' Since that time, I knew that getting known abroad required being reported on by influential newspapers and magazines and the media. This of course has nothing to do with artistic activity, but is something artists have to do. So in 1995 I began a series of fake covers of well-known foreign publications with my own face on them."[8] The headline, "Too Materialistic, Too Spiritualized," on his *Fake Cover: Newsweek* (1995; fig. 37), signals the pitfalls of entering the international art world as representative of a stereotyped group.

During the 1990s exhibitions of contemporary Chinese art popped up all over the world. Although at first this trend seemed promising, eventually it became obvious to concerned observers that such exhibitions were a dead end. They introduced Chinese art to the world as a monolithic entity, capable of being covered with the one exhibition. Once a museum had "done" Chinese art, what then? Furthermore, such exposure did not lead quickly to invitations to participate in major exhibitions of international artists.

### Exhibiting

As Zhou Tiehai emblazoned on his painting, *Press Conference* (1997; fig. 38), "The relations in the art world are the same as the relations between states in the post Cold War era." Mirroring the way in which the wealthy nations have controlled post–Cold War international trade mechanisms to promote their own interests, Western curators and critics have set the standards for what is deemed world-class art. Chinese artists and critics expecting to see Chinese art rapidly adopted into the international art circuit were repeatedly disappointed when major exhibitions neglected to include Chinese artists. Particularly frustrating was the reception of Chinese art in the prestigious periodic showcase exhibitions, Documenta and the Venice Biennale, a frustration illustrated by Yan Lei (b. 1965) in his painting, *Are You among Those Invited to the Exhibition in Germany?* (1996; fig. 39), which has the look and feel of a

Fig. 35. Zhou Tiehai, *Un / Limited Space (4): The Shower*, circa 1998. Installation in progress, German Consulate General, Shanghai.

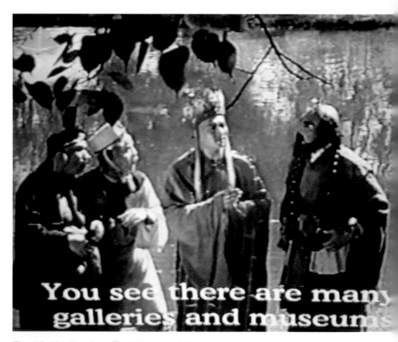

Fig. 36. Hu Jieming, *The Western "Journey to the West,"* 1998. Video.

Fig. 37. Zhou Tiehai, *Fake Cover: Newsweek*, 1995. Color print, 120 x 90 cm.

Cultural Revolution political campaign poster. Documenta included no Chinese art at all; what was included in the Venice Biennale was not treated on a par with Western art. Few people knew that the curator Harald Szeemann had invited China to send a major set of Socialist Realist sculptures, the *Rent Collection Courtyard* (1965–1978), to Europe for inclusion in the 1972 Documenta exhibition in Kassel. (No one in China had bothered to reply to the invitation.) Later, as curator of the Forty-eighth Venice Biennale in 1999, Szeemann selected the work of nineteen Chinese artists, an exciting departure and one that seemed to bode well for the future.[9] (Two years later, however, the Chinese presence at the event was greatly diminished.)

Why did Chinese artists feel so entitled to participate in important international exhibitions, and so surprised and resentful when participation did not equal their expectations? The Chinese art infrastructure had been dismantled during the Cultural Revolution, and as it has been reassembled and reinvented over the past three decades, certain structures and practices have led to the expectation of relatively easy access to exhibitions. The reconstitution of art academies during the 1980s provided some artists with secure positions and almost automatic invitations to contribute regularly to large exhibitions. Those working with unsanctioned styles or subjects remained outside the official art system, and could do no more than organize their own exhibitions in unofficial spaces. Nevertheless, as noted in chapter 1, more than 150 unofficial exhibitions and meetings took place in the later 1980s. By the late 1990s, independent curators were organizing often well-funded private exhibitions (that is, outside government control) in private galleries and alternative spaces. The quality of art in these exhibitions has been extremely uneven, with curators selecting for particular themes or for sheer number of artists, rather than for quality. The lack of critical vetting by curators reflects the undeveloped state of art criticism in China. This has afforded young untried artists access to a degree that would not be found elsewhere. Such a system may have its merits, but it has led to unrealistic expectations vis-à-vis the international art system.

### The China Card

The Venice Biennale in 1999 highlighted the issue of the "China card," a term translated from the Chinese

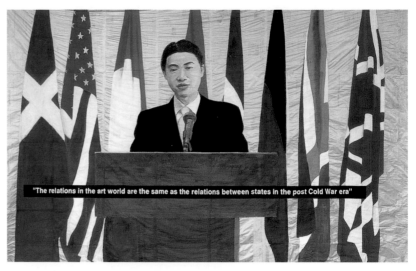

Fig. 38. Zhou Tiehai, *Press Conference 3*, 1999. Gouache and gold color on newspaper, 290 x 390 cm. Sigg Collection, Mauensee, Switzerland.

Fig. 39. Yan Lei, *Are You among Those Invited to the Exhibition in Germany?* 1996. Painting.

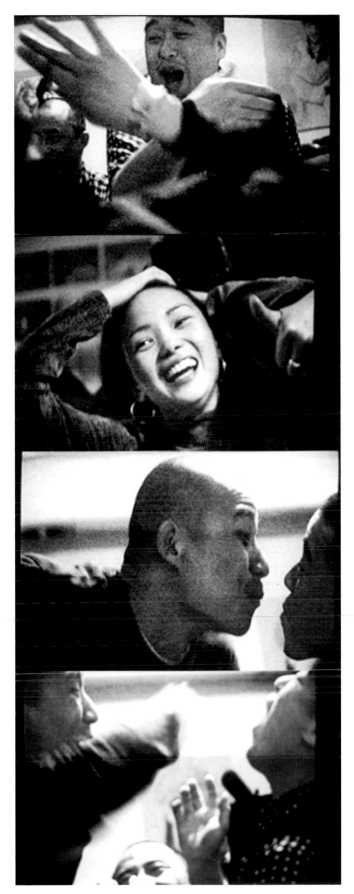

Fig. 40. Ying Bo / Ingeborg Lüscher, *Fei-Ya! Fei-Ya!—Fly Fly (Our Chinese Friends)*, 1998-99. Betacam video, 8 minutes.

*da Zhongguo pai* and used in a derogatory fashion. To "play the China card" in the art world is to attempt to gain an advantage by exploiting the perceived exoticism of patently Chinese art. Many Chinese critics believed that in 1999 Szeemann played the China card. Much of the Chinese art he selected bore markers of Chinese-ness and was identifiable as such. As a result, the press easily picked up on the China presence. Some of the artists who participated in the exhibition could themselves be described as having played the China card. Under the name of Ying Bo, Ingeborg Lüscher (b. 1963), Szeemann's wife, exhibited a video of Chinese people playing drinking games, *Fei-Ya! Fei-Ya!—Fly Fly (Our Chinese Friends)* (1998–1999; fig. 40). When her true identity emerged, many Chinese people were angry that she had usurped the Chinese identity in order to play the China card for her own gain. Ironically, they had missed the point: her work in fact proved that one must look beyond the superficial layer of Chinese-ness. As she says, the work is in part "a lesson about looking and prejudice."[10]

But the Chinese at home did not necessarily applaud the Western establishment's recognition of Chinese artists. They liked the recognition, but would have preferred it extended to artists who had not left China. At the same biennale Cai Guo-Qiang, a Chinese expatriate artist living in New York, won the International Prize for his installation, *Venice's "Rent Collection Courtyard"* (1999; fig. 41), a close copy of the Cultural Revolution sculptural installation that Szeemann had endeavored to show in Documenta in 1972. The awards committee lauded Cai Guo-Qiang for questioning "the history, function, and the epic of art through temporal and physical contextual isolation." But, resenting Cai's success, two Chinese factions attacked him. Misunderstanding the nature of his prize-winning installation, artists and institutions involved with the creation of the original *Rent Collection Courtyard* threatened to sue Cai for copyright infringement. For some, the desire to sue was tied to the perception that Cai no longer belonged to China because he had chosen to live in the United States, a country whose government was frequently demanding that China crack down on the illegal replication of copyrighted films and computer software. The threat of the lawsuit was so serious that Cai attempted to explain his working methods in China, in a series of bulletin boards (fig. 42) displayed at the Third Shanghai Biennale in 2000.[11]

The second group to criticize Cai had long derided Chinese artists living in the West for employing markers of Chinese-ness to attract a Western audience seeking exoticism. The fact that Cai won a major prize by, as they said, copying an important Chinese work of art fanned the flames of resentment. Speaking at the Third Shanghai Biennale seminar, the artist and critic Wang Nanming (b. 1962) declared that "by appropriating simple motifs or symbols left behind by tradition [overseas Chinese artists] formulate them into the 'essence' or mark of being Chinese. Such artists strategically seek to carve out a niche in which to survive within the order of the dominant race" (the Caucasians).[12] Along with Cai, he singled out Chen Zhen, Wenda Gu, and Huang Yong Ping for this criticism—all of them artists whose fame overseas surpassed that of most avant-garde artists living in China.

For their part, artists who have emigrated to the West recognize that distance has increased their interest in their native culture. Huang Yong Ping has said, "I was very interested in the West when I was in China. I considered it as something outside of me and it provided a source for my imagination. . . . I talk more about China now that I am in the West."[13] Yang Jiechang explains it thus: "I am a Chinese living in Europe. I cannot be rid of my Eastern background. My experience makes me look at things not just in black and white, but focus on the central gray tone. Not concentrating on right and wrong, I go east with my back to the east; the farther I go, the bigger the distance of gray, and the more possibilities."[14]

### "Can Foreigners Understand Chinese Art?"
"Over the course of the last ten years [that is, during the 1990s], Westerners have begun to introduce Chinese avant-garde art to the world, mostly through exhibitions at institutions in the West. But, do Westerners really understand Chinese avant-garde art? The answer I believe, is no."[15] With the control of important international exhibitions largely in the hands of Western—particularly European—curators, the uneven power relationships easily breed misunderstandings and resentment. Exacerbating the imbalance is the fact that most collectors of Chinese avant-garde art are Westerners. Few of China's nouveaux riches wish to sink their money into avant-garde art, preferring early paintings and porcelains as an avenue of widely recognized conspicuous consumption. Questions raised with increasing

Fig. 41. Cai Guo-Qiang, *Venice's "Rent Collection Courtyard,"* June 1999. Installation, Arsenale, Forty-eighth Venice Biennale.

Fig. 42. Cai Guo-Qiang, *Seasons: Self-Promotion for the People*, November 2000. Installation in notice board boxes outside the Shanghai Art Museum, Third Shanghai Biennale.

frequency in China include: Can foreigners understand Chinese art? Do foreigners appreciate Chinese art primarily for its exoticism? Are artists whose works look Chinese catering to the foreign audience? Are artists whose works look Western no more than copyists?

At an initial glance the first question, "Can foreigners understand Chinese art?" is ridiculous. Of course, some Westerners will produce such unfortunate comments as: "It is lamentable . . . that a culture as rich and deep as China's looks so familiar"[16]—this from a review in Charleston, North Carolina, in 2003, of an exhibition of works by the prominent figure painter Yu Hong (b. 1966), whose paintings capture the mundane reality of everyday life (fig. 43), but do not, evidently, live up to the reviewer's expectations of exoticism. It is silly to expect *all* foreigners or even all *Chinese* to understand Chinese avant-garde art. This question becomes quite serious, however, when we consider that a leading curator of recent important Chinese government-sponsored overseas exhibitions did once comment that "foreigners do not understand Chinese art."

As Chinese art itself has become less enmeshed in politics, Western consumption of Chinese art has become ever more bound up with politics. When Chinese avant-garde artists first began selling art overseas, long before China had developed into a world economic power, the government may not have appreciated the art, but it assuredly welcomed the additional source of foreign exchange. Eventually, observing the growing financial solvency of the artists, the government determined to try to understand the phenomenon. Government representatives purportedly visited Tongxian, a rural area on Beijing's outskirts where numerous artists live, to learn about art from Li Xianting, who had earlier been prohibited from working as a curator following the closure of the *China/Avant-Garde* exhibition. (A probable spoof of this episode, *Night Revels of Lao Li* [fig. 44] shows Li Xianting posing as an official who is being spied upon by the artist.[17] ) Recently realizing that it could use avant-garde art as a subtle diplomatic tool, an echo of the Cold War–era's Ping-Pong diplomacy, the government has officially endorsed exhibitions of avant-garde art to present an attractive face to the world and to suggest that China welcomes cultural exchange and permits all manner of freedom. *Living in Time: 29 zeitgenössischer Künstler aus China* [Living

in time: 29 contemporary Chinese artists from China], the first group show of contemporary art presented overseas by the Chinese Ministry of Culture, opened at Berlin's prestigious National Gallery at the Hamburger Bahnhof in 2001. China's appointee to the curatorial team of three was Fan Di'an, who has been the lead curator for the two subsequent, officially endorsed exhibitions in 2003, *Alors, La Chine?* [What about China?] at the Pompidou Center in Paris and the ill-fated Chinese Pavilion at the Fiftieth Venice Biennale. Fan Di'an's introduction in the Chinese Pavilion exhibition catalogue clearly links the project of sponsoring contemporary art exhibitions with the nation's political goals: "Like China's recent entry into the World Trade Organization, its hosting of the 2008 Olympics in Beijing and its hosting of the 2010 World Expo in Shanghai, China's establishment of a National Pavilion at the Venice Biennale in 2003 demonstrates yet again that China has become an inseparable part of the international community."[18] In the event, the Chinese exhibit itself was cancelled, officially because it was impossible to travel during the SARS epidemic. Almost certainly, the cancellation was the result of other, internal factors.[19]

## Positive and Negative Fantasies

While crowing about such important achievements as joining the Word Trade Organization and hosting the 2008 Olympics, China also drums up neonationalist sentiment by portraying, as symptomatic of high-handedness or as deliberate slights, such events as the Olympic Committee's denial of China's earlier bid for the 2004 Olympic Games, the delay in admitting China to the World Trade Organization, the failure to admit China to the G8 (Group of Eight world economic powers), or the American demand that China float its currency. For its part, the United States dwells on the politically expedient nightmare of a Chinese economy grown so large that it is dragging the American economy down because, for example, its currency is artificially pegged to the dollar, it is taking on out-sourced American jobs, or it is driving up world oil prices by increased oil consumption. For both countries this is the flip side of the dream of the exotic other. In the Chinese art world, resentment of largely European control of the arts merges with resentment of Western political and economic power—mostly American—as one big blur.

## A New Paradigm

Disenchanted with the structure of the art world, some artists have been seeking new models. They would like to disengage themselves from any degree

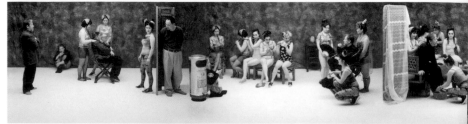
Fig. 44. Wang Qingsong, *Night Revels of Lao Li*, 2000. Chromogenic print, 120 x 960 cm.

Fig. 43. Yu Hong, *Routine—Undressing*, 2002. Acrylic on canvas, 178 x 152 cm.

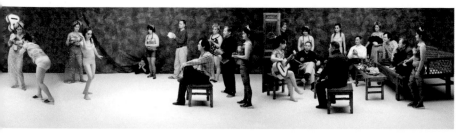

of dependency on the Western art world and reject the system that acknowledges the judgment of critics and curators and places art in institutional settings, notably museums, a construct with a Western origin. "We were very clear about what we wanted to say towards Chinese institutions as well as Western curators and institutions and dealers; their functions are all similar in one way or the other. It's all about the deal, about labor, how to trademark different interests. We had to say something as individual artists to the outside world, and what we said was 'fuck off.'"[20] Ai Weiwei thus describes the motivation behind the most notorious exhibition of Chinese art, *Fuck Off* (2000). Curated by Ai and Feng Boyi, and timed to coincide with the influx of curators into Shanghai for the opening of the widely anticipated Third Shanghai Biennale, the show was given a titillating title in English and a bland one in Chinese: *Bu hezuo fangshi*, which translates as "uncooperative approach." Participating artists aimed to propose new ways of making art, and a new art language. Works of art included traditional Chinese landscapes executed on pork (fig. 45), a complete room from the historic Shenyang Rolling Steel Mill, conceptual photography, an artist driving a forklift through his painting *Life in the Void of the Decay of Capitalism*, a sardonic poster invitation (fig. 46) to the Shanghai Biennale that was widely disseminated via e-mail, and a dog skeleton sealed into a glass case supposedly filled with a highly poisonous gas that could kill everyone in the gallery in three minutes (fig. 47). Predictably, the exhibition was closed down and the catalogues, which included more confrontational and shocking material, confiscated—but not until most of the foreigners had left town.

Other notable projects designed to reevaluate or redirect contemporary Chinese culture are the Long March Project and the Edges of the Earth Project, the one focusing on the interior of the country; the other, on the outside world. In 2002 more than 140 Chinese and foreign artists participated in the *Long March: A Walking Visual Display* (fig. 48), under the direction of Lu Jie as chief curator and his co-curator, Qiu Zhijie.[21] Traversing segments of Mao Zedong's six-thousand-mile Long March (1934–1935) across China, the artists indicated that their major goal was to engage the local townspeople and peasants in their art projects, enlisting their support as Mao had endeavored to enlist the support of the people for his cause.

Fig. 45. Huang Yan and Zhang Tiemei, *Flesh Landscape I*, 2000. Acrylic on pork. Photographed at *Fuck Off* exhibition, Eastlink Gallery, Shanghai, 4 November 2000.

41

Sponsored by the China Academy of Art in Hangzhou, the Edges of the Earth Project enabled the art historian Gao Shiming and a small team to travel throughout Asia in 2003, looking for commonalities and variables in visual culture. They documented their findings with photography and video, and published a report, *Edges of the Earth: Migration of Contemporary Asian Art and Regional Politics*.[22]

## Conclusion

In the 1990s the romantic dream image of China became a potent force shaping the presentation and reception of Chinese art in the West. "The West, as everyone knows," said Christine Buci-Glucksmann, "has never stopped dreaming of China: the China of the twenties and thirties, of the foreign concessions and of that most mythical of cities, Shanghai. But if all dreams imply myths, complex games of illusion and disillusion, then . . . Chinese contemporary art has seized the dream and is reflecting our fantasies back to us by an ironic and distorting mirror."[23] Now, while many Chinese artists have rejected the role of cultural other to the West, some are looking for their own cultural other, and finding it in China's rural population or in the non-West. There will always be a measure of curiosity about what one is not; to find an "other" can be to find a valuable and educational mirror.

So far, the twenty-first century promises to offer a wide variety of experiences and opportunities for Chinese artists both at home and abroad. The Chinese presence at major international exhibitions has reached a reasonable and sustainable level; and it seems that every year brings additional periodic shows ( biennials, triennials, and the like), particularly in Asia, where many nations have made a concerted effort to provide new venues for cultural exchange. With ample choices, artists can better afford to decline invitations for activities, in China and out, whose ulterior agendas or approaches they find objectionable. The increasing richness of opportunities does much to readjust the balance of power in the art world, so that we can look forward to an even more enjoyable and productive give-and-take between China and the West in the future.

Fig. 46. Xu Tan, *Shanghai Biennale, Awaiting Your Arrival,* 2000. Poster / Internet poster, JPEG format, 965 KB, sent by Yahoo.com.

Fig. 47. Sun Yuan, *Solitary Animal,* 2000. Dog skeleton, glass case, so-called poison gas. Installed at *Fuck Off* exhibition, Eastlink Gallery, Shanghai.

Fig. 48. Jiang Jie, *Sending Off the Red Army: In Commemoration of the Mothers on the Long March,* 26 September 2002. *Long March— A Walking Visual Display* exhibition, Moxi, Sichuan, 26 September 2002.

## Notes

1.  Disney Online, World Showcase Land. http://disneyworld.disney.go.com/wdw/parks/attractionDetail?id=ReflectionsofChinaAttraction Page (accessed 30 May 2004).
2.  Julia Andrews, "Black Cat White Cat," 26.
3.  Hans Van Dijk, "Painting in China," 33.
4.  Ibid., 34.
5.  Francesca Dal Lago, in an unpublished paper "From Crafts to Art: Chinese Artists at the Venice Biennale,1980–2001," has made a detailed examination of the history of China's participation in the Venice Biennale.
6.  Geremie Barmé, *In the Red*, 192.
7.  For more on the subject, see Britta Erickson, "Reception in the West."
8.  Zhou Tiehai, "Lecture by Zhou Tiehai: *Placebo-Swiss* at Hara Museum," ShanghART web site, 24 October 2000. http://www.shanghartgallery.com/texts/zhoutiehai5.htm (accessed 8 October 2004).
9.  For more about the Chinese presence at the 1999 Venice Biennale, see Francesca Dal Lago, "Chinese Art at the Venice Biennale."
10. Ingeborg Lüscher, e-mail message to author, 5 May 2004.
11. For more on the turmoil surrounding Cai's Venice's "Rent Collection Courtyard," see Britta Erickson, "Il Cortile per la Riscossione."
12. Wang Nanming, "The Shanghai Art Museum," 266–67.
13. Hou Hanru, "Plaisir du Texte," 65
14. Chen Tong, "The Central Color."
15. Zhu Qi, "Do Westerners Really Understand?" 55.
16. Kristen Rhodes, "Yu Hong at the Halsey," *Post and Courier Charleston.net*, 3 June 2003. http://www.charleston.net/stories/060303/spo_03halsey.shtml.
17. This photograph is modeled after an early Chinese painting, *Night Revels of Han Xizai*, supposedly painted by Gu Hongzhong (act. 943–960), who was commissioned by the emperor to spy upon and document the vice premier's licentiousness.
18. *Synthi-Scapes*, 5. Martina Köppel-Yang also cites this very telling quotation—and delves more deeply into this subject—in "Ping-Pong Diplomacy."
19. The Italian government would have required only a check for fever before permitting the Chinese Pavilion artists, who were to have traveled directly from China to Italy, to enter the country. Numerous other artists from China, traveling to Italy via France, did attend the biennale.
20. *Ai Weiwei Works*, 51.
21. The Long March Foundation continues to organize exhibitions and events from its headquarters, 25000 Cultural Transmission Center, in Beijing's new arts center, Factory 798. For more information, see the Long March Foundation web site: http://www.longmarchfoundation.org/.
22. Xu Jiang, ed., *Edges of the Earth*.
23. Jean-Marc Decrop and Christine Buci-Glucksmann, *Modernités chinoises*, 7; translated by Sophie Smith.

Part One: The West through a Political Lens

Part Two: Cultural Mélange

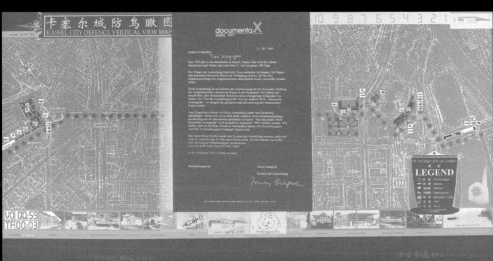

Part Three: Joining the Game

**THE EXHIBITION**

Qiu Zhijie   Xu Bing   Zhang Hongtu

Hong Hao   Sui Jianguo   Yan Lei   Yin Xiuzhen   Zhou Tiehai

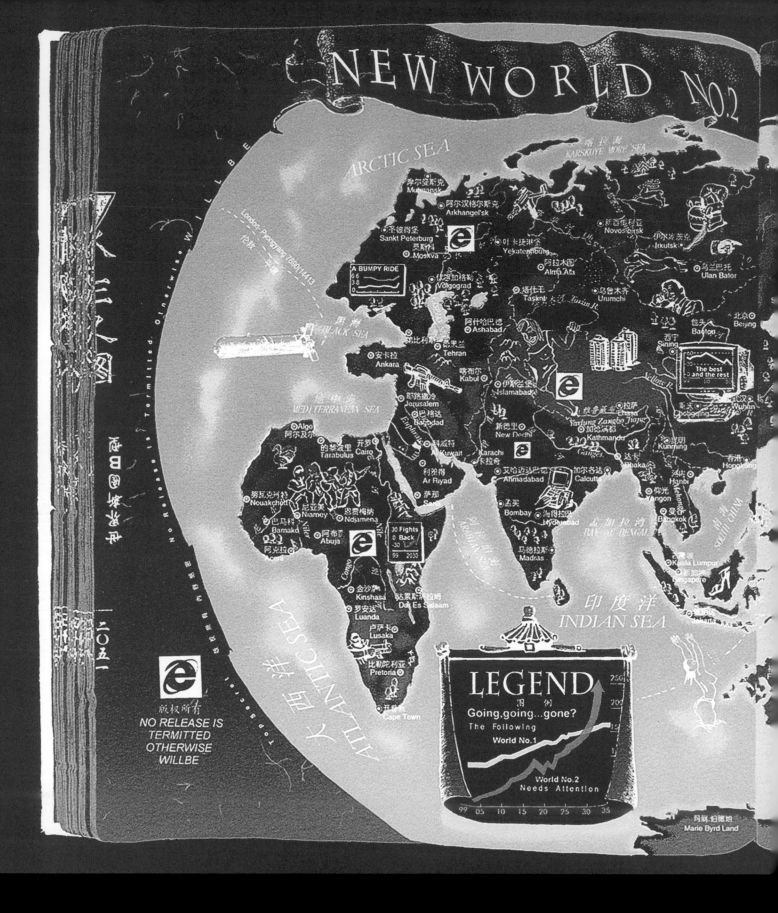

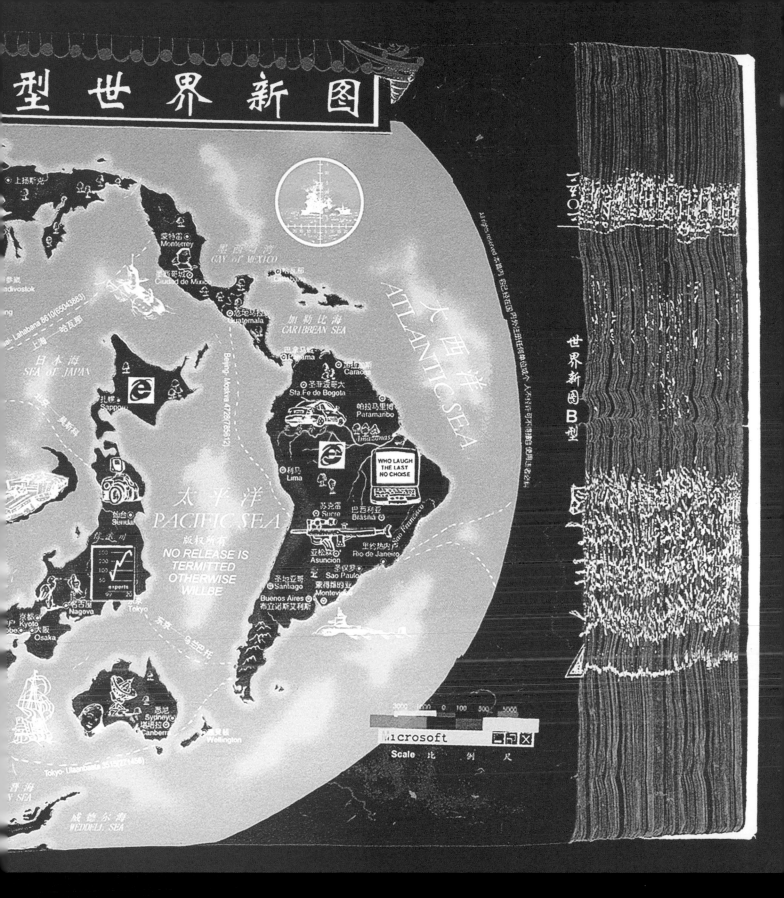

THE WEST THROUGH A POLITICAL LENS

# Hong Hao

Hong Hao, *Selected Scriptures, Page 2001: New World No. 1*, 2000
Silkscreen print, 55 x 79 cm
Christophe W. Mao Collection
Hong Hao, *Selected Scriptures, Page 2051: New World No. 2*, 2000
Silkscreen print, 55 x 75 cm
Christophe W. Mao Collection

Since graduating from the Print Department of the Central Academy of Fine Arts in 1989, Hong Hao (b. 1965) has continuously refined his skill in the art of silkscreen printing. He is a perfectionist and will layer the prints from dozens of separate screens to produce a single image, rich in detail. Since 1992, Hong has silk-screened a series of more than thirty tromp l'oeil images representing the pages of an open book called the *Selected Scriptures*. The print that is designated as page 1 is the *Preface*; page 3561 is the *Postscript*; and the remaining prints bear page numbers scattered in between. Hong uses the framing device of the open book, and the title *Selected Scriptures*, to evoke the aura of respect accorded to books in general and to religious texts in particular. Surely ancient scriptures amounting to 3,561 pages must catalogue enormous amounts of important knowledge! Indeed, the *Selected Scriptures* are filled with weighty concepts, but they are far from being repositories of long-respected factual and cultural information. Juxtaposing the familiar with the strange, Hong's prints are simultaneously disquieting and humorous, and succeed in jolting their audience into a fresh awareness of the world.

In the earliest *Selected Scriptures* prints, Hong combined icons of the Cultural Revolution with symbols of capitalistic culture, thus earning a place with the Political Pop artists. *Selected Scriptures, Page 3137: The Holy Caves* (1992; fig. 49), for example, depicts staunchly heroic figures from the revolutionary opera, *Raise the Red Lantern*, alongside a bikini-clad woman, all framed by the arches of a Buddhist sculpture grotto. What differentiates Hong Hao's work from much of the early 1990s Political Pop is the artist's concern not just with the clash between memories of the Cultural Revolution and the onslaught of commercialism but also with traditional

Fig. 49. Hong Hao, *Selected Scriptures, Page 3137: The Holy Caves*, 1992. Silkscreen print, 51 x 74 cm.

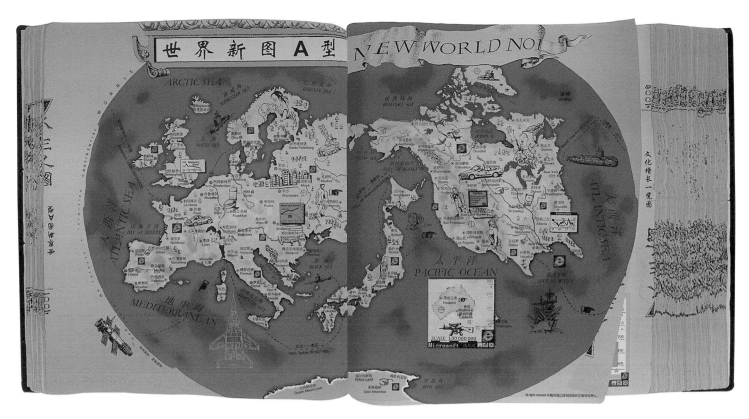

Fig. 50. Hong Hao, *Selected Scriptures, Page 2001: New World No. 1*, 2000. Silkscreen print, 55 x 79 cm.
Christophe W. Mao Collection.

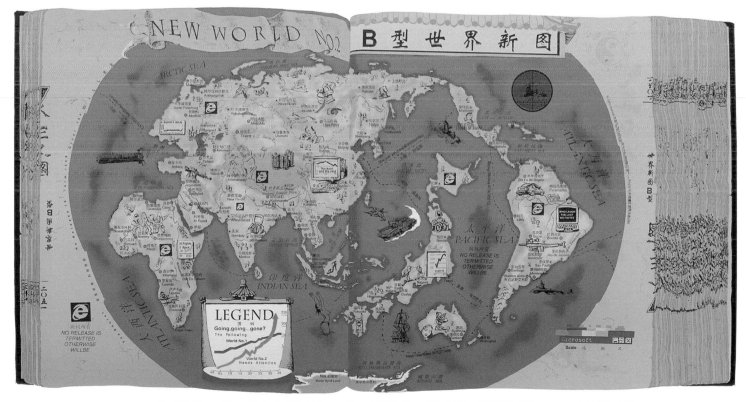

Fig. 51. Hong Hao, *Selected Scriptures, Page 2051: New World No. 2*, 2000. Silkscreen print, 55 x 75 cm.
Christophe W. Mao Collection.

Chinese culture and contemporary international politics and economics.

Several of the *Selected Scriptures* prints show fanciful variants on the world map. People rarely think to question the reliability of maps, whose primary purpose is to convey factual information with particular accuracy. As Hong has said, "I have long been interested in maps, especially historical maps, because they are capable of inspiring ideas on what we take as common knowledge. They are also the most direct and the most economical way to know the world."[1] Hong's reworkings of the world map range from the playful to the acerbic and disquieting. In one, *Page 2121: The New Geological World* (1995), the placement of water and land is reversed; in another, *Page 1862: The Division of Nuclear Arms* (1994), he delineates a world so heavily armed that even Antarctica bristles with missiles; in another, *Page 3535: The New World Geomorphology* (1996), he portrays an absurd contemporary world, charting consumption habits, stock market trends, and the availability of computers and cellular telephones in place of the more familiar (and in many ways outdated) symbols for such regional products as coal, grain, and livestock.

In *Selected Scriptures, Page 2001: New World No. 1* (fig. 50), the Third World has disappeared, but we do find it represented in *Selected Scriptures, Page 2051: New World No. 2* (fig. 51), along with a legend charting the rise of "World No. 2," which "needs attention." The world seems to have split in two, with only Australia, Antarctica, and a hugely out-of-proportion Japan appearing in both maps. Perhaps the Internet Explorer logos peppered over both worlds suggest a linking device.

Fig. 52. Hong Hao, *Spring Festival on the River*, 1999–2001. Photograph, 60 x 120 cm

Fig. 53. Hong Hao, *My Things No. 8*, 2003. Photograph, 127 x 216 cm.

The subject matter appearing on the open pages of the *Selected Scriptures* does not always make sense, but there is a tight internal logic to the overall book format. A large V-shaped tear appears on the top right of *Page 203: The Miracles of the Holy Caves* (1995). The same rip shows up on *Page 1522: The Art of War, Sunzi* (1994) and has become even larger by *Page 1657: Holy Images through the Dynasties, Gathering Herbs* (1994), but has disappeared by *Page 1818: Acupuncture Therapy: The Hemp Cloth Phrenology* (1994). Hong Hao has made his fictitious tome credible by his extreme attention to detail.

Prints constituted the main body of Hong's oeuvre in the 1990s; more recently he has been creating large photomontages, addressing some of the same issues and artistic concerns that appear in the *Selected Scriptures. Spring Festival on the River* (1999–2001; fig. 52), for example, uses a new medium to recreate the appearance of an old. A panoramic photograph of the path from the east entrance to Beijing along Changan Avenue, the city's central axis, the work is modeled after a famous twelfth-century handscroll, Zhang Zeduan's *Spring Festival along the River* (c. early 12th cent.; Palace Museum, Beijing). *My Things No. 8* (2003; fig. 53) continues Hong's interest in tromp l'oeil: the artist scanned each object, fitted the images together using a computer program, and printed them exactly life-sized in the finished work.

1. Joris Escher and Martijn Kielstra, eds., *Selected Scriptures*, 16.

# Huang Yong Ping

## Exhibition Works →

Huang Yong Ping, *Bat Project I, II, III Memorandum*, 2001-2004
Installation, with photographs and paper, approx. 6 x 1.5 x 4 m
Collection of the artist

Throughout his career, Huang Yong Ping (b. 1954) has been interested in the artificiality of cultural constructs. As a founding member of the group Xiamen Dada, he sought to undermine the institutions of art, citing the influences of Chan Buddhism, Daoism, and Marcel Duchamp (1887–1968) as his precedents. *"The History of Chinese Painting" and "A Short History of Modern Painting" after Two Minutes in a Washing Machine, December 1987* (1987, remade 1993; see fig. 13), for example, the presentation of two leading art historical texts as pulped paper, demonstrated his deep mistrust for the creation of art canons. After moving to Paris in 1989, he became interested in a broader kind of cultural construct, that of national and cultural divisions. *Entrée* (1993; fig. 54) obliged gallery visitors to declare a choice of citizenship, choosing between doors labeled "EC Nationals" or "Other," as they would when going through airport immigration formalities. *One Man Nine Animals* (1999; fig. 55) attacked the institutions of art and stood as a meta-phor for the drastic changes that can ensue when two cultures collide. As one of two artists representing France in the Forty-eighth Venice Biennale, Huang sculpted nine creatures drawn from the early Chinese classic, *Shanhai jing* [Classic of mountains and oceans] and foretelling drastic change, such as drought, war, and disease. Seemingly uncontainable within the neoclassical French Pavilion—representing a legacy of logic—the fantastic Chinese creatures loom over it, atop wooden pillars piercing the pavilion's roof.

The forced landing of the United States Navy EP-3 Aries spy plane in southern China in spring 2001 created an international incident and incensed the Chinese people. It also captured Huang's imagination as he observed events from the distance of Paris:

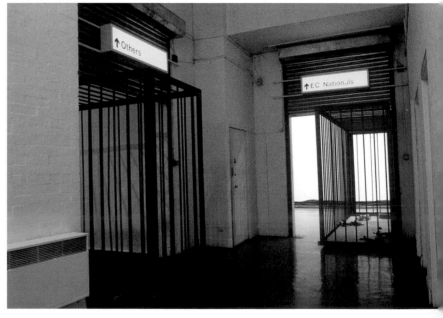

Fig. 54. Huang Yong Ping, *Entrée*, 1993. Installation, with cages, lion excrement, illuminated signs, 10 x 8 x 3 m. *Coalition* exhibition, Centre for Contemporary Art, Glasgow, Scotland.

Fig. 57(left). Huang Yong Ping, *Bat Project I, II, III Memorandum*, 2001–2004 (details). Installation, with photographs and paper, approx. 6 x 1.5 x 4 m. Collection of the artist.

Fig. 58(right). Huang Yong Ping, *Bat Project I, II, III Memorandum*, 2001–2004 (details). Installation, with photographs and paper, approx. 6 x 1.5 x 4 m. Collection of the artist.

As his entry in a French-Chinese sculpture exhibition at the He Xiangning Museum in Shenzhen, Huang submitted a proposal for a full-sized re-creation of a portion of the cut-up spy plane. Instead of being disassembled in a scientific manner, as the American technicians had done, he presented the plane chopped up in a Chinese fashion, as one would a cake or sausage (fig. 56).The proposal had been approved by both the French and the Chinese authorities as a French entry in the exhibition, when officials at the French consulate in Guangzhou became nervous and attempted to persuade the artist to withdraw the piece from the exhibition. When he proved unwilling, the French embassy became involved, hinted at pressure from the Chinese and American governments, and persuaded the museum to remove the piece from the exhibition. It sat anonymously for over a year in a public park, until Huang was allowed to reassemble it in 2003.

In November 2002, Huang built a second replica of the spy plane, *Bat Project II*, commissioned for the Guangzhou Triennial. Following a series of exchanges between the American consulate and the Guangdong Museum of Art (the venue of the exhibition), and despite extensive protests by Huang and other participants in the exhibition, *Bat Project II* was unceremoniously cut into pieces and carted away as junk before the exhibition opened. Since then, the piece has been reclaimed by the artist and is now in the collection of the Guy and Myriam Ullens Foundation in Brussels.

In commenting upon a diplomatic incident, *Bat Projects I* and *II* themselves created diplomatic incidents, albeit on a much smaller scale, and demonstrated the extent to which cultural misunderstandings can inflate an issue beyond its original significance.This work is a particularly successful example of artistic intervention in cultural politics.

Fig. 55. Huang Yong Ping, *One Man Nine Animals*, 1999. Wood and aluminum. Installation, the French Pavilion, Forty-eighth Venice Biennale.

*Bat Project III* (2003), financed by a private corporation that was sponsoring an exhibition in Beijing, was censored by the corporation after its completion, for reasons that remain unclear. For details of the trials and tribulations of the Bat Project, see *Bat Project History*, pp. 120–33.

*Bat Project I, II, III Memorandum* (2001–2004; figs. 57, 58) is a work documenting the three Bat Projects. It is presented as a looping piece of film covered with photographs and text, suggestive of the many cameras that have been turned on this series of installations by the press, by the diplomatic corps, and by the art world.

1. Mona Chollet, "France-Chine: Un avion bien encombrant," *Libération*, 12 December 2001.

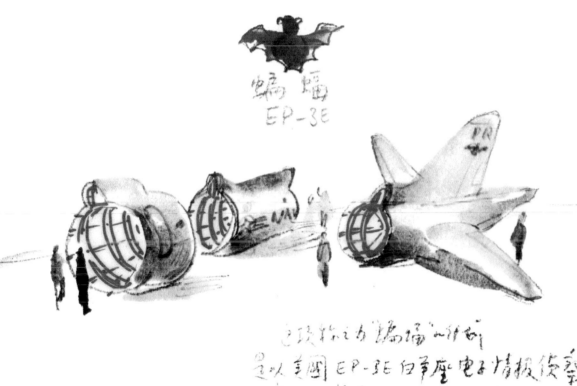

附件 1-A

Fig. 56. Huang Yong Ping, *Proposal for Bat Project I*, 2001. Watercolor on paper.

# Wang Du

## Exhibition Works

Wang Du, *Youth with Slingshot*, 2000
Resin, fiberglass, acrylic paint, 120 x 190 x 110 cm
Fashion Concepts, Inc. Collection

In 1986 Wang Du (b. 1956) and two other artists in Guangzhou established the Southern Art Salon, one of the most notable groups of the '85 Art Movement. Their *First Experimental Exhibition* (1986) made innovative use of space, engaging performers in choreographed movements within a setting of painted surround and sculptural ground.[1] Wang had recently taken up a teaching post in the Plastic Arts Department of the South China Polytechnic University, and his participation in the avant-garde group acted as counterpoint to the conservative approach favored in academic institutions.

The course of his career changed dramatically when he emigrated to Paris in 1990, after being imprisoned for participating in the demonstrations that took place across China in 1989 and culminated in the massacre in Beijing's Tiananmen Square. Wang has said that, for him, the most significant influence after he moved to Paris was the relentless onslaught of information, coming not only from television, newspapers, and the like, but also in the bulletins of everyday life, such as bills and notices received in the mail.[2] Since then he has used the bombardment as fodder for his sculpture.

His work plays up the distorting effect the media have on our perception of world events. He lifts images from the print media, re-presenting them as sculptural enlargements. The sculptures are faithful to the original two-dimensional image, amputated where the picture frame cuts them off, and with the perspective exaggerated. These distortions are drawn from the artist's literally superficial reading of the source images. The distortions in our understanding of world events, as derived from the media, are equal in scale, but run much deeper.

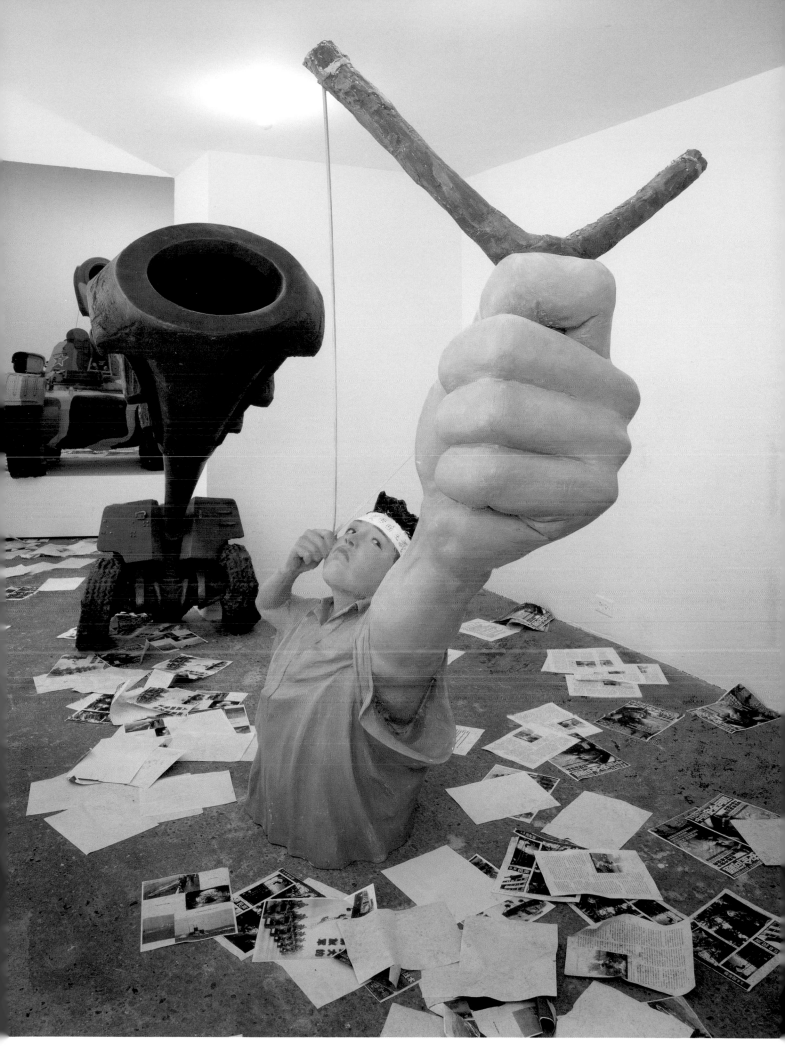

Fig. 59. Wang Du, *Youth with Slingshot* (foreground), 2000. Resin, fiberglass, acrylic paint, 120 x 190 x 110 cm. Fashion Concepts, Inc. Collection.

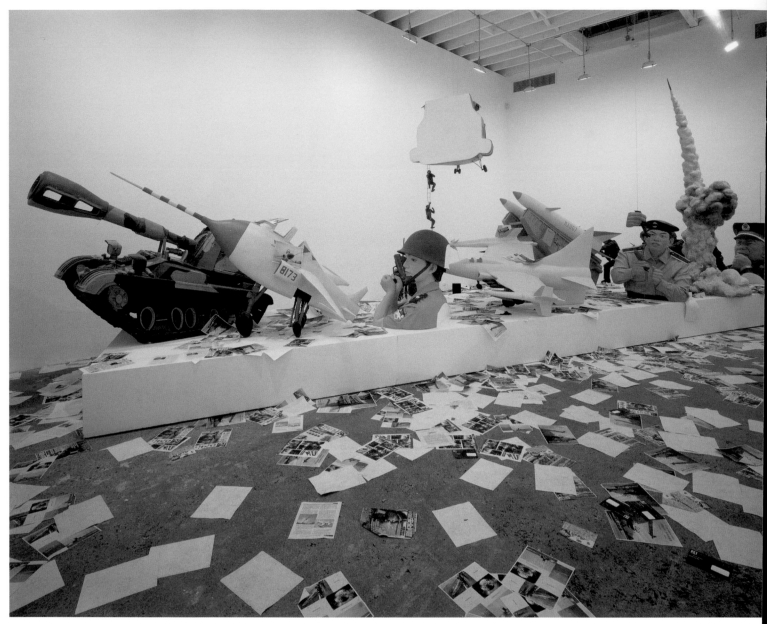

Fig. 61. Wang Du, *Défilé*, 2000. Installation, resin, fiberglass, acrylic paint. Deitch Projects, New York, 11 November through 23 December 2000.

*Youth with Slingshot* (fig. 59) was modeled after a news photograph (fig. 60) of a crowd outside the American embassy in Beijing, protesting the 1999 NATO bombing of the Chinese Embassy in Belgrade, during the war in the former Yugoslavia. The sculpture is part of *Défilé* [Parade], a sculptural installation based on images of armaments and military technology presented in the Chinese media (fig. 61). "In China," said Wang Du,

> it is clear that the media are entirely at the service of political objectives, and that strong political intentions lie behind the circulation of public information. The images of Défilé show that the military information massively broadcast by the Chinese media is not limited to the display of arms and military technology, but represents the country's power as a political stake in a politico- spiritual war against the supposed enemy: that enemy being none other than the U.S.[3]

An artist with an abiding social conscience and a strong belief in art's ability to contribute to change, Wang Du describes his approach thus: "Contemporary art is, in my opinion, a social act that intervenes in reality with a catalytic and fermenting energy. . . . *Défilé* is based on the idea of intervening in the conflict of ideologies and the attempt to obtain a certain 'political montage.'"[4]

1. Gao Minglu et al., *Zhongguo dangdaimeishushi*, 374.
2. *Gare de l'Est*, exh. cat. (Luxembourg: Casino Luxembourg—Forum d'art contemporain, 1998), 141.
3. Wang Du, "Letter to Jeffrey Deitch," in Pierre Bal-Blanc, ed., *Wang Du Magazine*, 4/18.
4. Ibid.

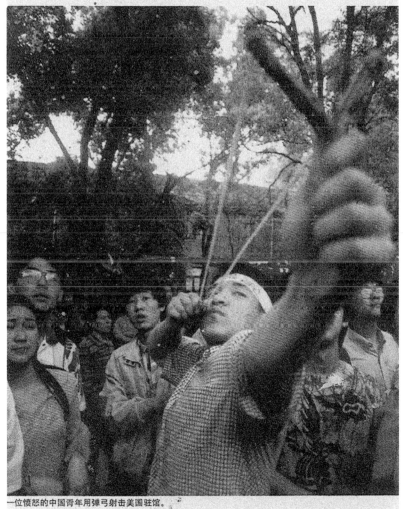

,T队伍高喊着"战犯"、"刽子手"等抗议口号。

一位愤怒的中国青年用弹弓射击美国驻馆。

Fig. 60. Wang Du, Source for *Youth with Slingshot*, 2000; publication unknown.

# Xing Danwen

## Exhibition Works →

Xing Danwen, *disCONNEXION series: a3*, 2002-2003
Chromogenic print, 148 x 120 cm
Collection of the artist
Xing Danwen, *disCONNEXION series: a6*, 2002-2003
Chromogenic print, 148 x 120 cm
Collection of the artist
Xing Danwen, *disCONNEXION series: b2*, 2002-2003
Chromogenic print, 148 x 120 cm
Collection of the artist

As a photographer Xing Danwen (b. 1967) has shifted between the roles of photojournalist and artist, but is being pulled inexorably toward a deeper exploration of photography as an artistic medium. She shot her first rolls of film at Tiananmen Square, during the historic demonstrations there in 1989.[1] From 1990 to 1993 she traveled the far-flung reaches of China, producing stunning black-and-white portraits of the people of Gansu, Xinjiang, and Tibet, and of the coal miners of Datong. Back in Beijing, fortuitously connecting with the newly formed East Village artists' community, she became one of the two important photographers documenting the germinating performance art movement (the other being Rong Rong). Her edgy style (fig. 62) perfectly complemented the attitude of the moment.[2]

From 1998 to 2000, Xing studied photography at the School of Visual Arts in New York. There she moved away from documentary work to create the experimental *Scroll* series (fig. 63). Double-exposed and mounted in the traditional Chinese handscroll format, the photographs of the series evoke a dreamy nostalgia with an ironic twist. The nostalgia is derived both from the artist's distance from her homeland and from her increasing sensitivity to the dislocation between modernity and tradition.

This awareness was amplified when she moved back to China and traveled to Guangdong Province on assignment. Her task was to document the villages where imported electronic trash is recycled (fig. 64). Although a growing quantity of such trash is being generated by China's own electronics industry, most of it is imported from the United States, with smaller but significant amounts coming from Japan and South Korea; the world exports seventy percent of its electronic trash to China.[3] In her artist's statement for the *disCONNEXION* series, Xing Danwen wrote of

Fig. 62. Xing Danwen, *A Personal Diary of Chinese Avant-garde Art in China in 1990's: Ma Liuming, Beijing*, 1993–1998. Chromogenic print. Collection of the artist.

Fig. 65. Xing Danwen, *disCONNEXION* series: a3, 2002–2003. Chromogenic print, 148 x 120 cm. Collection of the artist.

Fig. 66. Xing Danwen, *disCONNEXION* series: a6, 2002–2003. Chromogenic print, 148 x 120 cm. Collection of the artist.

Fig. 67. Xing Danwen, *disCONNEXION* series: b2, 2002–2003. Chromogenic print, 148 x 120 cm. Collection of the artist.

her trips to the area:

> Along the coast, more than a hundred thousand
> people from Guangdong and migrant workers from
> Western China make their living by recycling piles
> of computer and electronic trash, operating in
> rough environment[al] and social conditions. . . .
> Confronted with vast piles of dead and
> deconstructed machines, the overwhelming
> number of cords, wires, chips and parts, with
> the clear indication of the company names,
> model numbers, and even [names of] individual
> employees, I felt shocked. . . .
>
> Modernization and globalization shape urban
> development. In my country, I have experienced
> and witnessed the changes that have taken place
> under the influence of Western modernity. These
> changes have contributed to a strong and powerful
> push for development in China, but at the same
> time they have led to a big environmental and
> social nightmare in remote corners of China.[4]

The trash is shipped to coastal distribution centers,
where villagers buy the trash, process it, and resell
what they can salvage. Typically, each village special-
izes in one product, such as wires, cell phones,
monitors, or circuit boards. This recycling provides a
livelihood for a hundred thousand people. But those
people do not understand the environmental degrada-
tion brought about by the haphazard manner in which
they reclaim recyclable materials: the drinking water in
the town of Guiyu, for example, contains twenty-four
hundred times the level of lead considered safe by the
World Health Organization.[5] But the side effects of
burning plastic components to retrieve heavy metals
are more immediately apparent than those of lead in
the water: eighty percent of the children in some
towns suffer from respiratory and skin diseases, a
development not lost on the villagers.[6]
Xing Danwen completed her journalistic assignment
over the course of several visits to the villages.
Although shocked by the situation, she also recognized

Fig. 63. Xing Danwen, *Scroll B1*, 1999–2000. Chromogenic print, 19 x 254 cm. Collection of the artist.

Fig. 64. Xing Danwen, *Picking Trash #3*, 2002–2003.
Photograph. Collection of the artist.

the allure of the homogeneous mountains of e-trash. Her *disCONNEXION* series photographs (figs. 65–67) engage the viewer by presenting close-ups of materials that appear familiar, yet are somehow also strange—once-coveted high-tech consumer goods reduced to piles to be mined for raw materials.

1.   Unfortunately, those images are lost.
2.   For more, see Xing Danwen, *Wo-Men*.
3.   "China Battles World's IT Trash," *Australian*, 2 December 2003. http://www.theaustralian. news.com.au/printpage/ 02C59422C80407872C00.html.
4.   Xing Danwen, *Danwen.com*.
5.   Rachel Shabi, "The E-Waste Land," *Guardian*, 30 November 2002. http://www.guardian.co.uk/weekend/story/ 0,3605,849530,00.html.
6.   "China Battles World's IT Trash."

# Zhang Huan

## Exhibition Works →

Zhang Huan, *My New York*, 2002
Video
Collection of the artist
Zhang Huan, *My New York*: #1, 2002
Chromogenic print, 100 x 150 cm
Collection of the artist
Zhang Huan, *My New York*: #4, 2002
Chromogenic print, 150 x 100 cm
Collection of the artist

Living in the East Village artists' colony on the outskirts of Beijing, Zhang Huan (b. 1965) became one of China's leading performance artists in the early 1990s. Although he had trained as a painter, his innate sense of drama and timing led to the discovery of performance as a medium more suited to the sentiments he felt compelled to express. Many of his first performances masochistically explored the abject extremes to be experienced by an individual, and were a reflection of the dire circumstances under which he and his cohorts lived and worked. For *12 Square Meters* (1994; see fig. 28), one of his best-known early works, he sat for an hour, unmoving, in the village latrine. To enhance the element of endurance, he plastered fish paste and honey over his body to attract flies. *Angel* (1993; fig. 68), a performance with dolls and red paint, expressed a sense of the tragedy of the women in his circle who underwent multiple abortions. Other performances from this period involved his hanging, bound and helpless, from the rafters as blood dripped from his arm to sizzle on a hot plate below (*64 Kilograms*, 1994); his being left alone, locked in a metal box (*Metal Case*, 1994); and his lying beneath the sparks cast by a steel-threading machine (*25mm Threading Steel*, 1995). Dispassionately recording technical aspects of the events, such as the artist's weight, the titles contrast starkly with the extreme conditions of the performances.

In the late 1990s, following his move to the United States and dramatic changes in his personal situation, Zhang began investigating issues of sensitivity and pain within other social groups. The resulting performances, masterfully orchestrated events tailored to their locations, include *My America (Hard to Acclimatize)* (1999), *My Australia* (2000), *Pilgrimage to Santiago* (2001), and *My New York*. Because each performance requires elaborate preparations and can be physically and mentally

Fig. 68. Zhang Huan, *Angel*, 1993. Performance, National Art Gallery of China, Beijing. Collection of the artist.

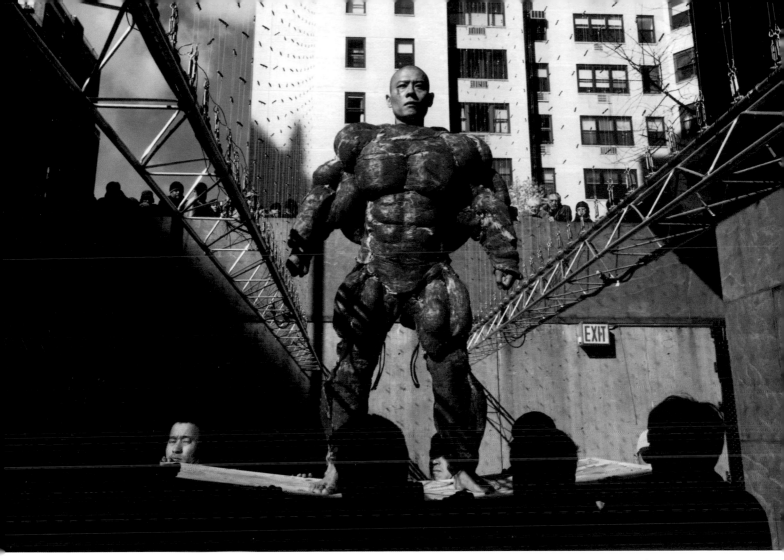

Fig. 70. Zhang Huan, *My New York: #1*, 2002. Chromogenic print, 100 x 150 cm. Collection of the artist.

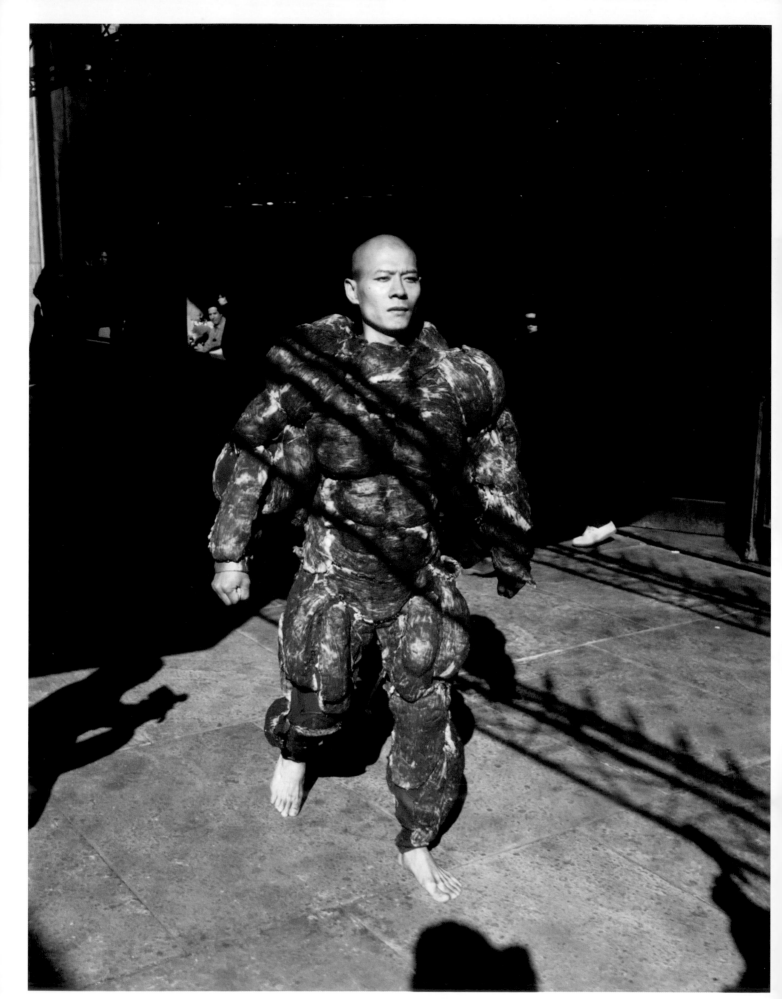

Fig. 71. Zhang Huan, *My New York*: #4, 2002. Chromogenic print, 150 x 100 cm. Collection of the artist.

demanding, the artist limits himself to two or three each year. He has found other outlets for his creativity in staged photographs and large-scale installations and sculptures, for example *Peace 1* (2001; fig. 69), a bronze cast of his own body poised to strike a bronze bell, symbolizing a personal search for peace.

Commissioned by the Whitney Museum of American Art in New York, the performance *My New York* (figs. 70, 71) is an acknowledgment of the people of New York as "having a strong sense of strength; having a sense of being [themselves], of being New Yorkers . . . a declaration of strength unique to the people of New York,"[1] and presents the artist's wish for the United States in the wake of 9/11. For the performance, Zhang donned a body-builder costume constructed from strips of beef, to personify America's avatar as superpower. Following a display of raw (literally) strength, Zhang strode through the streets of New York, releasing doves along the way. Doves represent peace and their release evokes the Buddhist notion of accruing grace through the freeing of living animals. Believing that the United States should take on the role of peacemaker, using its might to promote compassion, Zhang Huan also warns about the side effects of building up power:

> *Something may appear to be formidable, but I will question whether or not it truly is so powerful. Sometimes such things may be extremely fragile, like body builders who take drugs and push themselves beyond the limits of their training on a long-term basis, until their heart cannot possibly bear such enormous stress. . . . A body builder will build up strength over the course of decades, becoming formidable in this way. I, however, become Mr. Olympic Body Builder overnight.*[2]

1. Zhang Huan, artist's lecture, Wattis Institute for Contemporary Arts at the California College of the Arts, San Francisco, 8 April 2004, as recorded by Jordan Miller.
2. Zhang Huan, artist's statement: *My New York.*

Fig. 69. Zhang Huan, *Peace 1*, 2001. Cast bronze, 3.4 x 3.7 x 2.4 m.

# Zhou Tiehai

Zhou Tiehai, *Civilization*, 2004
Acrylic on canvas, set of three paintings, 200 x 510 cm overall
Collection of the artist

Zhou Tiehai (b. 1966) was born and educated in Shanghai, a city that became a worldly metropolis as a result of the nineteenth-century collision between China and the West. Historically open to radical philosophies, Shanghai sheltered Lu Xun (1881–1936) as he taught young artists the new woodcut manner in the 1930s; it witnessed the most extreme actions of the Red Guards during the Cultural Revolution; and its current cultural and economic innovations surpass those of China's other cities. Zhou Tiehai is a radical thinker suited to this milieu.

Although his early artistic activities clearly left him unsatisfied, incidental aspects of each have contributed to his present career. At the Fine Arts School of Shanghai University, Zhou received an education typical for artists his age, with an emphasis on styles derived from Socialist Realism. He did not finish the program, but took away an understanding of color and the use of emotionalism in large-scale paintings. Willing to experiment, in 1986 he participated in the Shanghai-based "M" Art Group's performance, *Violence*.[1] The overt performance genre may be at odds with his personal style (his involvement with "M" Art Group is rarely mentioned), but he has since developed an approach to art that could be considered a long-term, very subtle kind of performance. In 1991 he stopped painting for three years to make television commercials. Knowledge gained from that venture has been put to use to plot a film, *Will* (1997), and to create a series of paintings based on it (see the script and paintings, reproduced in this catalogue; see pp.145–53). Zhou returned to the art world in 1994 with two goals in mind: he resolved never to make art by his own hand and he was determined to establish relations with the Western art world. "I feel," he said, "it is not the vital thing for an artist to paint. What counts is how to make others believe you are a good artist. That's why I devote all my time to convincing

Fig. 72. Zhou Tiehai, *Civilization*, 2004. Acrylic on canvas, set of three paintings, 200 x 510 cm overall. Collection of the artist.

others. . . . This is a large project. The key of my plan is to work outside my studio."[2] Now Zhou Tiehai's occupation consists of conceptualizing works of art, supervising their creation, and interacting with art-world figures, such as curators, critics, collectors, dealers, and publishers to promote their belief in his art. The latter activity may be the most important: he has remarked that in the future he may even hire others to do the thinking for him.[3]

Most of Zhou Tiehai's works from the 1990s comment on the international art world. He created the *Fake Cover* series (see fig. 37) as a sardonic observation that Western curators recognized only those Chinese artists already prominently featured in Western publications. *Will* follows the travails of young Chinese artists as they "see the doctor" (*kan bing*, a term meaning to show work to a Western curator), plan a new airport to bring more curators, meet the imposing art-world Godfather, and ultimately wind up adrift on the Raft of the Medusa.

*Civilization* (figs. 72, 73), which presents the peaceful image of an airplane against a gold-toned sky, is of a different tenor from most of his oeuvre. Visually, it brings to mind Gao Jianfu's painting, *Flying in the Rain*, a quiet vista of airplanes hovering in a yellow-washed sky (see fig. 1). Gao Jianfu was renowned for his paintings of airplanes—a symbol of China's modernization that was important to the Kuomintang (the KMT or Chinese Nationalist Party) and reflected in the party's slogan, "Aviation to Save the Country."[4] Gao's paintings clearly supported the KMT's nationalistic stance; the motivation behind Zhou Tiehai's *Civilization* is less clear. In recent years, the Chinese government has condoned, and even encouraged, anti-American nationalism among China's youth and intellectuals. Both the NATO bombing of the Chinese Embassy in Belgrade and the forced landing of the U.S. Navy EP-3 Aries spy plane in southern China catalyzed dramatic waves of Chinese nationalism. Smoothly airbrushed, Zhou's rendering of the American surveillance airplane is untouched by the emotionalism that still rages around the spy plane incident. The airspace at first appears nonspecific, until we notice that the ocean is modeled after a well-known painting of waves by the great Chinese master, Ma Yuan (active ca. 1190–1225) and its sepia tone is derived from the yellowed silk of the original.[5] Usually a sardonic observer of international interactions, Zhou in this instance combines a muted irony with a semblance of rational neutrality.

1. Gao Minglu et al., *Zhongguo dangdai meishushi*, 386.
2. Shu Yang, ed., *Purity: A Dip Interview with 103* (Hong Kong: Culture of China Publication Co., 2002), 631.
3. Ibid.
4. Ralph Croizier, *Art and Revolution*, 100.
5. Ma Yan, *Waves*, ink on silk, 26.8 x 41.6 cm, Palace Museum, Beijing.

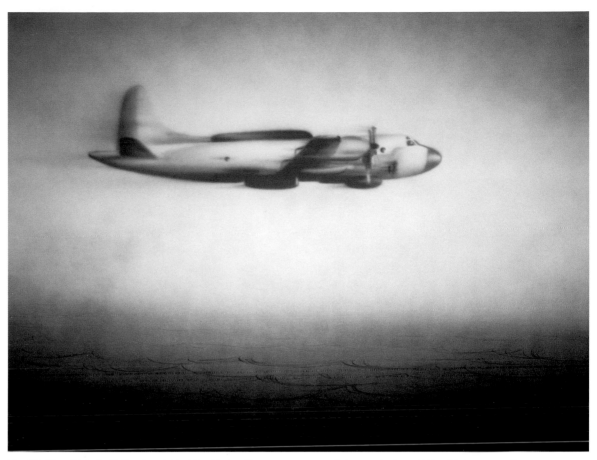

Fig. 73. Zhou Tiehai, *Civilization*, 2004 (detail). Acrylic on canvas, set of three paintings, 200 x 510 cm overall.
Collection of the artist.

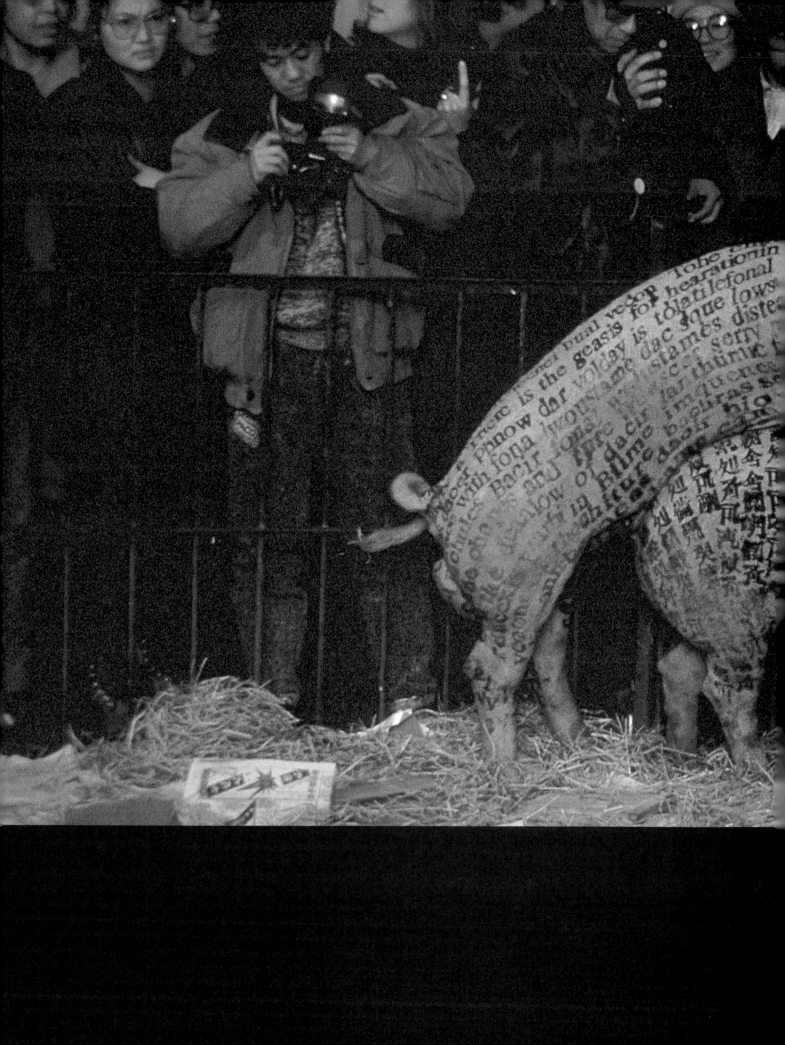

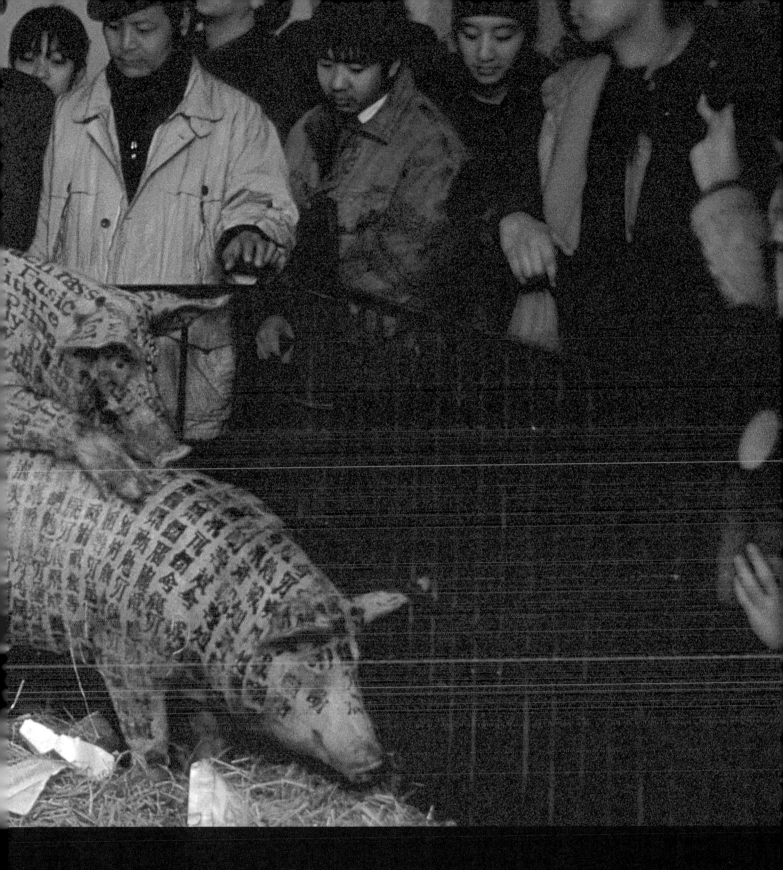

CULTURAL MÉLANGE

# Qiu Zhijie

## Exhibition Works →

Qiu Zhijie, *Grinding the Stele*, 2001
Performance resulting in a video and ten ink prints on handmade
paper, mounted as five hanging scrolls; each scroll, 225 x 77.5 cm
Video, Qiu Zhijie Collection
Prints, Ethan Cohen Collection

An artist, curator, critic, and teacher, Qiu Zhijie
(b. 1969) is one of the most active and widely known
figures in the Chinese art world. As a curator, his
projects have been intended to explode conventions.
The most notorious, *Spree* and *Post-Sense
Sensibility, Alien Bodies and Delusions* (co-curated
with Wu Meichun), included works made from
animals and human body parts.[1] More recently, in a
search for a new, Chinese (or non-Western) approach
to art and exhibitions, his projects have included *Long
March: A Walking Visual Display* and the Edges of the
Earth Project, both discussed in chapter 2 (see pp.
41–42). The Edges of the Earth project was con-
ducted under the aegis of the China Academy of Art,
where Qiu teaches in the New Media Department,
the first such department in China. In his writings Qiu
Zhijie is inclined to extol a nationalistic point of view,
for example employing Marxist thinking to laud the
virtues of importing Western artistic styles,
manufacturing new works from them, and then
reselling them to the West.[2] A sharp, prolific artist,
Qiu Zhijie works in numerous media, employing
techniques ranging from traditional brush and ink and
rubbings to photography, video, installation, and
interactive CD-ROM.

A frequent underlying theme in Qiu Zhijie's work is
the obscuring or obliteration of a subject via repetition
or layering. His well-known *Writing the "Lanting
Pavilion Preface" One Thousand Times* (1992–1995;
fig. 74) involved his copying a famous piece of
calligraphy over and over on the same piece of paper
until the text disappeared. This work suggests that, in
the process of copying, which was the method by
which Chinese calligraphic masterpieces were
preserved through the centuries, the spirit of the
original is obliterated. *Tattoo II* (1997; fig. 75) is a
photograph of the artist with the boundaries of his
body overwritten and obscured by the large red
character *bu*, meaning "no" or "not."

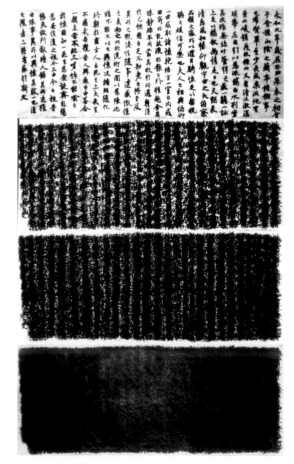

Fig. 74. Qiu Zhijie, *Writing the "Lanting Pavilion Preface"
One Thousand Times*, 1992–1995. Performance with ink
on paper; calligraphy, 75 x 80 cm.

Fig. 76. Qiu Zhijie, *Grinding the Stele*, 2001 (detail of the grinding). Performance resulting in a video and ten ink prints on handmade paper, mounted as five hanging scrolls; each scroll, 225 x 77.5 cm. Video, collection of the artist; prints, collection of Ethan Cohen.

Fig. 77. Qiu Zhijie, *Grinding the Stele*, 2001 (detail of the unmounted prints). Performance resulting in a video and ten ink prints on handmade paper, mounted as five hanging scrolls; each scroll, 225 x 77.5 cm. Video, collection of the artist; prints, collection of Ethan Cohen.

Similarly, *Grinding the Stele* (figs. 76, 77) involves both text and obfuscation. For this work, Qiu obtained two gravestones, that of a two-year-old American girl, who died in 1915, and that of a person from the Qing dynasty (1644–1911). After making an ink rubbing of each stone, he began a three-week process of grinding the faces of the two stones together, until neither inscription remained. At regular intervals he made rubbings from the stones, to document the gradual erasure of the texts. Although we know little about either of the deceased, we understand immediately from the appearance of the inscriptions that these two people were born into different cultures. At the end of it all, however, with the text reduced to dust, there was little to distinguish the stones. Is this what will happen in the future, with the long-term grinding together of the United States and China? Is the artist commenting on the fact that, without distinctive cultural conditioning, people are remarkably similar? Or is he warning us that, without unique cultural markers, we are nothing? Either way, in the end we all turn to dust.

Fig. 75. Qiu Zhijie, *Tattoo II*, 1997. Silver print, 180 x 145 cm.

1.  Qiu Zhijie and Wu Meichun, *Post-Sense Sensibility*.
2.  Thanks to Kela Shang for bringing this example to my attention.

# Qiu Zhijie

## Exhibition Works

Qiu Zhijie, *The West*, 2000
Interactive CD-ROM
Collection of the artist

Fig. 78. Qiu Zhijie, *The West*, 2000 (detail).
Interactive CD-ROM. Collection of the artist.

Fig. 79. Qiu Zhijie, *The West*, 2000 (detail).
Interactive CD-ROM. Collection of the artist.

Qiu Zhijie's artist's statement on *The West* reads:

*The Chinese embassy in Yugoslavia was bombed by NATO in the summer of 1999. I was in Beijing at that time and noted the bedlam in front of the American and British embassies. This turbulent event demonstrated the complicated way in which Chinese people conceive of the West. Inspired by this, I began to make the CD-ROM work,* The West.

*Actually, this concrete political event was just one of the reasons I created* The West. *For a long time, I have used my art to bring attention to situations in which people are controlled without being conscious of that fact. The concept, "The West," is a most complicated and inexplicit state, riddled with varied historical and factual elements. It is also self-contradictory, sometimes serious, sometimes farcical. For this reason, interactive multimedia is the best way to present the feeling of the West. It must become a kind of investigation, but retain the feel of a game so as to show the complexity of the reality, particularly the fantasticality of the reality.*

*The West is the end of [the] Silk Road, the West is the powerful aggressor, the West is the terrible and ugly beast with brown hair, the West is the wellspring of democracy and freedom. The West means advanced technology, the West means the rich life, the West is what China is now open to, but then, it is also the enemy because of the bomb. The West is not a geographical concept but an imaginary entity.*

*Because of the complexity of this subject, this CD-ROM work is impossible to finish: it is an ongoing project. Feedback from the audience will provide new materials for it, so that the work becomes a maze, just like this concept itself.*

Fig. 80. Qiu Zhijie, *The West*, 2000 (detail: contemporary architecture). Interactive CD-ROM. Collection of the artist.

Fig. 81. Qiu Zhijie, *The West*, 2000 (detail: Coca-Cola advertisement). Interactive CD-ROM. Collection of the artist.

Fig. 83. Qiu Zhijie, *The West*, 2000 (detail: European flying machine, late 19th cent.). Interactive CD-ROM. Collection of the artist.

Fig. 82. Qiu Zhijie, *The West*, 2000 (detail: tourist kitsch). Interactive CD-ROM. Collection of the artist.

As an interactive CD-ROM, *The West* (figs. 78, 79), by Qiu Zhijie allows the viewer to roam at will through a tangle of Chinese ideas about the West. Hilarious misperceptions exist side-by-side with the kinds of insight that can be gleaned only through an outsider's perspective. Video clips, interviews, and more than a hundred still images are sorted into such categories as "The Good West," "The Bad West," and "The Real West." The West appears as a source of style, from the European architectural design of the Qing-dynasty garden and palace complex Yuan Ming Yuan (destroyed by Western forces in 1890) to contemporary fashions and architecture (fig. 80). The desire for Western style and consumer goods resulted in the last emperor's donning a Western suit, the import of Minnie Mouse (clad in Tang-dynasty court dress), and the popularity of Coca-Cola (fig. 81). A complementary rush to manufacture export goods produces tawdry ceramic Chinese lions and Bruce Lee statuettes (fig. 82). It appears that the mutual incomprehension between East and West is destined to produce quantities of kitsch and the occasional work of harmony and beauty. Beauty itself is a nebulous concept: in the video one interviewee states that as a child he thought Westerners were ugly; a second interviewee adds, "Of course, they have a terrible smell."

For a century, the West has stood for advanced science and technology, which are both enticing and threatening. A late–Qing dynasty imagined view of a European city depicts a bizarre flying machine (fig. 83); twentieth-century China was thrilled by America's space program. A hundred years ago Chinese students studied medicine in Europe and America; now people avidly consume cheap copies of Western drugs such as Viagra, available on the street. Superior weaponry facilitated Western imperialism; in the twenty-first century, American weapons technology generates fear and resentment in China. All of these elements appear in video.

The CD-ROM format of *The West* is ideally suited to conveying a strong sense of the way in which pop culture, high culture, and politics are inextricably intertwined. Centuries of miscomprehension have created an enticingly messy interface between China and the West, and Qiu Zhijie has devised a means for Westerners to view that tangled skein from the other side.

# Xu Bing

Xu Bing, *Square Word Calligraphy Classroom*, 1994-1996
Mixed media interactive installation: twelve desk, chair, and bookrest
sets; blackboard, brushes, ink, and inkstones; copybooks and tracing
books; video
Collection of the artist

Surrounded by books from a very early age, Xu Bing (b. 1955) has long been fascinated by words—by their look and by their power. With the advent of the Cultural Revolution in 1966, the allure of language shifted for the artist, then eleven years of age. In the service of propaganda, words appeared everywhere, repetitive but not necessarily to be taken at face value. They heralded persecutions: it was from a "big character" poster denouncing Xu Bing's father, the chairman of the History Department at Beijing University, that he learned that his father was being persecuted as a political reactionary. At school, Xu's careful and beautiful writing brought him the responsibility of writing blackboard newsletters and "big character" posters. Later, sent to the country-side with other educated youth, he produced a newsletter for his village.

After the Cultural Revolution, Xu Bing was in the first class of students to enter the reopened Central Academy of Fine Arts in Beijing. He flourished in the Print Department, but found an unorthodox means of combining his love of words with his knowledge of print methods. He created the *Book from the Sky* (1987–1991; fig. 84; see also figs. 15, 16), a hand-printed set of books and scrolls in which every character was invented by the artist, but appeared at first glance to be genuine. The work thus presented the viewer with a puzzle necessitating a change of mental gears, much as a Chan (or Zen) koan does. Exhibited as a monumental installation, the *Book from the Sky* caused a sensation in Beijing art circles. It has since been widely acknowledged as one of the most important twentieth-century works of Chinese art.

Following his move to the United States in 1990, Xu Bing observed the awe and fascination with which Westerners regard Chinese writing. He determined to help them to enjoy the process of calligraphy and

Fig. 84. Xu Bing, *Book from the Sky*, 1988. Mixed media installation, with books, scrolls, wooden boxes. National Art Gallery of China, Beijing. Collection of the artist.

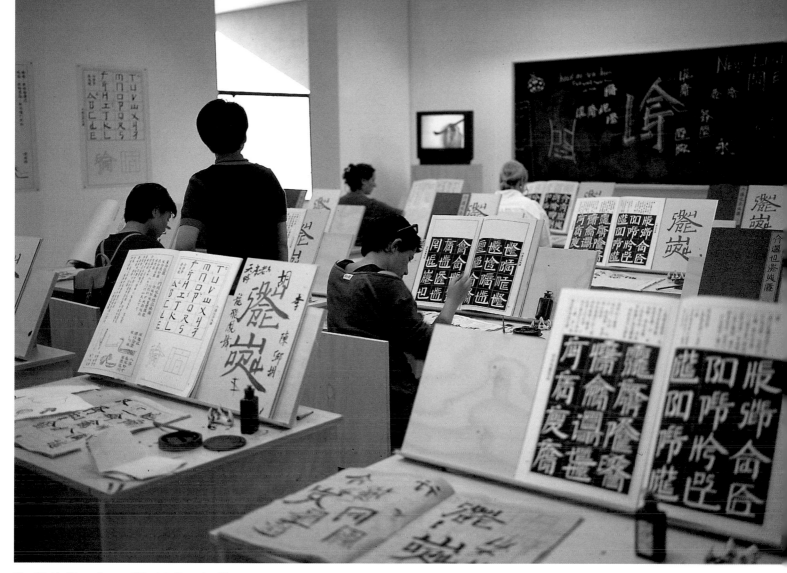

Fig. 85. Xu Bing, *Square Word Calligraphy Classroom*, 1994–1996. Mixed media interactive installation: desk, chair, and bookrest sets; blackboard; brushes, ink, and inkstones; copybooks and tracing books; video. Installation view, Institute of Contemporary Arts (ICA), London, 1997. Collection of the artist.

Fig. 86. Xu Bing, *Square Word Calligraphy Classroom*, 1994–1996 (detail). Mixed media interactive installation: desk, chair, and bookrest sets; blackboard; brushes, ink, and inkstones; copybooks and tracing books; video. Collection of the artist.

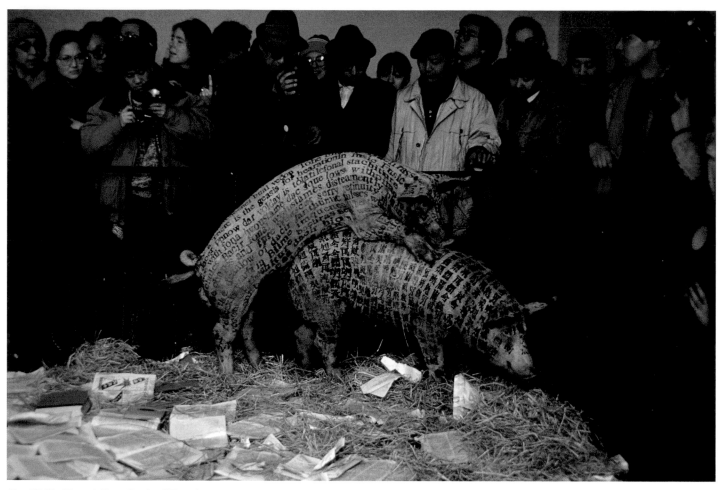

Fig. 87. Xu Bing, *A Case Study of Transference*, 1994 (detail, indoors). Performance, with pigs. The Han Mo Art Center, Beijing. Collection of the artist.

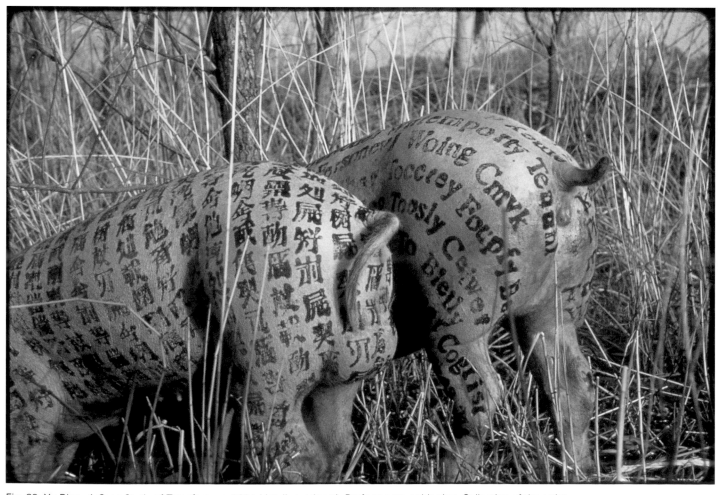

Fig. 88. Xu Bing, *A Case Study of Transference*, 1994 (detail, outdoors). Performance, with pigs. Collection of the artist.

Fig. 90. Xu Bing, *First Readers*, 2003 (detail. *Poop*). Glass. Collection of the artist.

Fig. 91. Xu Bing, *Where Does the Dust Itself Collect?* 2004. Installation, dust collected from the streets of New York following the attacks of September 11, 2001. Installed at the National Museum and Gallery, Cardiff, Wales. Collection of the artist.

drawing unfavorable attention to the Han Mo Arts Center, which had sponsored the first, clandestine event. The present installation of *A Case Study of Transference* exhibits videos of the two performances projected on opposing walls to convey the message that cultural influence goes both ways.

Since *A Case Study of Transference*, Xu Bing has continued to investigate the ways in which language guides our understanding of the world and of our place within it. These investigations have earned him such prestigious awards as a MacArthur Foundation Fellowship, the Fukuoka Asian Culture Prize, and the newly created Artes Mundi Award. *The Net* (1997; fig. 89), for example, presents language as an instrument of control: the cage in which two sheep are penned is formed from wire twisted into the words of the curators' exhibition statement.[1] Light-hearted works such as *First Readers* (2003) make plain our willingness to trust in the written word rather than in direct experience: the labels on a series of glass shapes guide our interpretation. A blob of glass (fig. 90) becomes either "poop" or "little sweet," depending on whether we read English or Chinese. More subtle is *Where Does the Dust Itself Collect?* (2004; fig. 91), a meditation on the intangibility of the material world and of human conceits. The work consists of a translation of lines from a poem by the Chan Sixth Patriarch Huineng (638–713)—"As there is nothing from the first, / Where does the dust itself collect?" [Benlai wu yi wu, / He chu re chen ai?]—left blank in a field of dust gathered from the streets of New York after 9/11.

1.  *Animal.Anima.Animus*, curated by Marketta Seppälä and Linda Weintraub, Pori Art Museum, Pori, Finland (6 June–30 August 1998).

# 卡塞尔城防鸟瞰图
## KASSEL CITY DEFENCE VERTICAL VIEW MAP

内容绝密 切勿外传 否则

Liebe(r) Frau/Herr

Tian Ming-y

Seit 1955 gibt es die documenta in Ka
documenta statt finden und zwar vom

Der Träger der Ausstellung freut sich,
Jahr besondere fianzielle Mittel zur V
Sonderausstellung mit zeitgenössische
sollen.

Diese Ausstellung ist ein Zeichen der
der zeitgenössischen chinesische Kuns
verpflichtet, den chinesischen Künstle
bieten. Der Titel der Ausstellung heiß
Avantgarde" - er spiegelt die galoppie
Kunst wieder.

Aus Zeitgründen können wir diese Au
ankündigen. Schon jetzt ist es nicht m
gleichzeitig mit der documenta stattfi
chinesiche Avantgarde" wird deshalb
hoffen, daß Sie für diese Situation Ve
wird No.16 Second quator Gnakupul,

Der Autor diese Briefes wurde zum K
vom 30. Juni bis zum 15. Juli nach CH
und alle nötigen Vorbereitungen vorz
(Tel 010 6507 3384, Fax 010 6507 33

In der Hoffnung, Sie in China zu sehe

Hochachtungsvoll

No.16 Second quarter Gnakupul ,Kasse

VO 00:59
TF 00:03

Confidential  No Release   Südflügel   Kulturbahnhof   Unterfuhrung Kulturbahnhof   Museum Fridericianum   Friedrichsplatz   Shoot   AHEAD界丸别墅街防(实)
Fragments Distribution of En

《卡塞尔城鸟瞰图》20/51

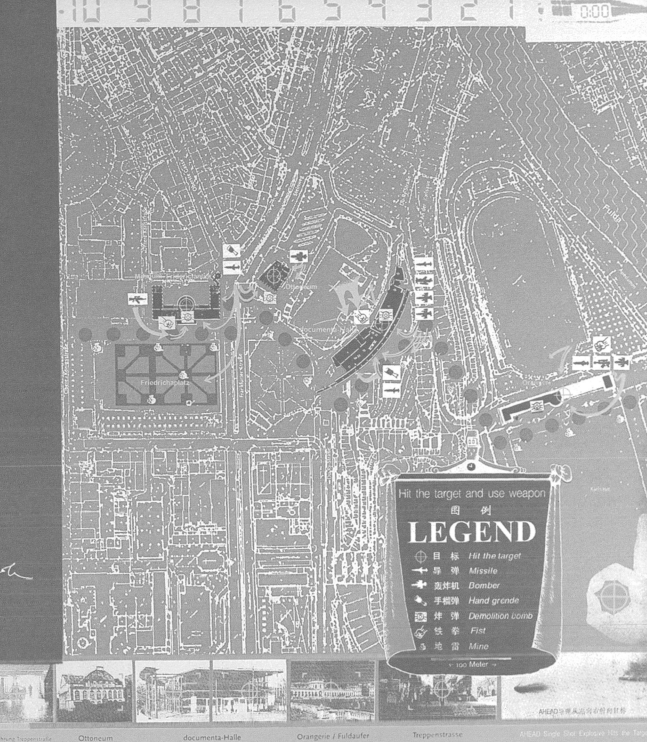

# JOINING THE GAME: THE CHINESE ARTIST MEETS THE WORLD

# Hong Hao and Yan Lei

## Exhibition Works →

Hong Hao and Yan Lei, *Invitation*, 1997
Three pieces: envelope, invitation, gallery floor plan; paper, 11 x 22 cm, 29.7 x 21 cm, 21 x 29.7 cm
Yan Lei Collection
Hong Hao, *Kassel City Defence Vertical View Map*, 1998
Silkscreen print, 56 x 76 cm
Christophe W. Mao Collection

In 1999, when the list of artists to be included in Documenta X, a major international art exhibition held in Kassel, Germany, was released, it included not a single Chinese artist. Many people were upset to hear this. Soon after, however, dozens of Chinese artists received invitations to submit their work for a special section of the Documenta. According to Ielnay Oahgnoh, the curator of the special exhibition, additional funding had been received unexpectedly and would be used for an ancillary exhibition, *From the Other Shore—An Exhibition of the Vanguard of Chinese Art*. The exhibition was intended to recognize the great strides made by Chinese artists in recent years, and to highlight the respect they had earned from the international art world. At the end of the letter, Ielnay Oahgnoh stated the date on which he would arrive in Beijing, and expressed his hopes that he would meet the artist there to discuss possible inclusion in the exhibition.

Eager recipients of Ielnay Oahgnoh's letter called the specified telephone number, but their calls went unanswered. Some, hoping to make contact with the elusive representative, even telephoned Germany or traveled to Beijing—at great personal expense—only to discover that it was all a hoax. The telephone number was that of a public telephone; the curator's name a fabrication.

For this elaborate hoax, the perpetrators, Hong Hao and Yan Lei (b. 1965), had invented the curator, giving him their own names spelled backward, made up stationery with the Documenta X logo, designed a gallery floor plan based on a friend's apartment, and arranged to have the letters mailed from Germany (figs. 98, 99). For a while, the two were extremely unpopular, but by now the story has passed into legend.

GRUNDRISS 1:220

documenta
KASSEL 1997
No.16 Second quarter Gnaleupuli .
Kassel , Germany

Mr. Ielnay Oahgnoh
Blk . B.6/F.123 Casle Peak Rd
Tsuen Wan
Hong Kong

Fig. 98. Hong Hao and Yan Lei, *Invitation*, 1997 (detail of gallery floor plan and envelope). Paper, 21 x 29.7 cm, and 11 x 22 cm. Yan Lei Collection.

# documenta X
KASSEL 1997

Liebe(r) Frau/Herr *Ielnay*                                    5 - 20 - 1997

Seit 1955 gibt es die documenta in Kassel. Dieses Jahr wird die zehnte documenta statt finden und zwar vom 21. Juni an genau 100 Tage.

Der Träger der Ausstellung freut sich, Ihnen mitteilen zu können, daß dieses Jahr besondere fianzielle Mittel zur Verfügung sstehen, die für eine Sonderausstellung mit zeitgenössischer chinesischer Kunst verwendet werden sollen.

Diese Ausstellung ist ein Zeichen der Anerkennung für die besondere Stellung der zeitgenössischen chinesische Kunst in der Kunstwelt. Wir fühlen uns verpflichtet, den chinesischen Künstlern diese einzigartige Gelegenheit zu bieten. Der Titel der Ausstellung heißt "Aus der anderen Welt - chinesiche Avantgarde" - er spiegelt die galoppierende Entwicklung der chinesischen Kunst wieder.

Aus Zeitgründen können wir diese Ausstellung leider nur kurzfristig ankündigen. Schon jetzt ist es nicht mehr möglich, diese Sonderausstellung gleichzeitig mit der documenta stattfinden zu lassen. "Aus der andere Welt - chinesiche Avantgarde" wird deshalb im September 1997 eröffnet werden. Wir hoffen, daß Sie für diese Situation Verständnis haben. Der Ausstellungsort wird No.16 Second quator Gnakupul, Kassel sein.

Der Autor diese Briefes wurde zum Kurator der Ausstellung ernannt, und wird vom 30. Juni bis zum 15. Juli nach China reisen, um die Künstler zu treffen und alle nötigen Vorbereitungen vorzunehmen.
(Tel 010 6507 3384, Fax 010 6507 3363)

In der Hoffnung, Sie in China zu sehen

Hochachtungsvoll                          Ielnay Oahgnoh

                                          Kurator der Ausstellung

No.16 Second quarter Gnakupull ,Kassel , Germany  TEL: 49561 - 65918  FAX: 49561 - 65103

Fig. 99. Hong Hao and Yan Lei, *Invitation*, 1997 (detail of invitation). Paper, 29.7 x 21 cm. Yan Lei Collection.

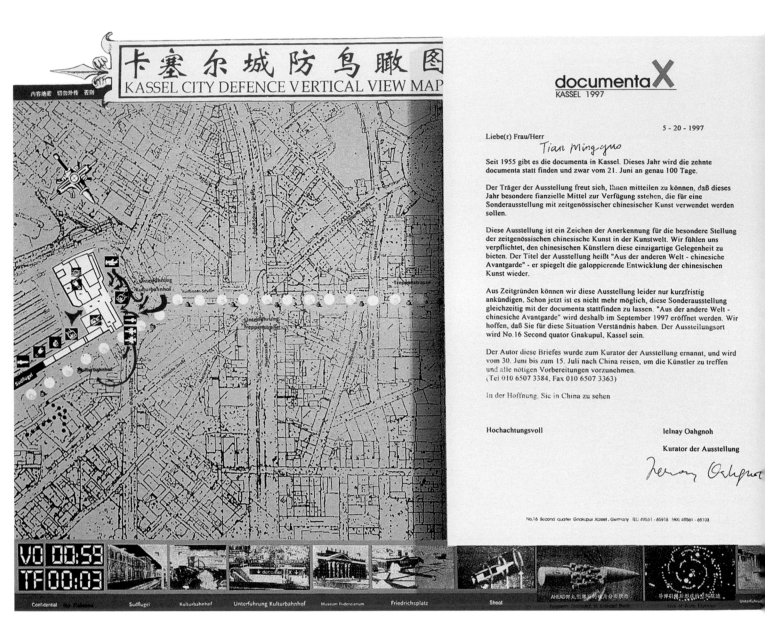

Fig. 100. Hong Hao, *Kassel City Defence Vertical View Map*, 1998. Silkscreen print, 56 x 76 cm. Christophe W. Mao Collection.

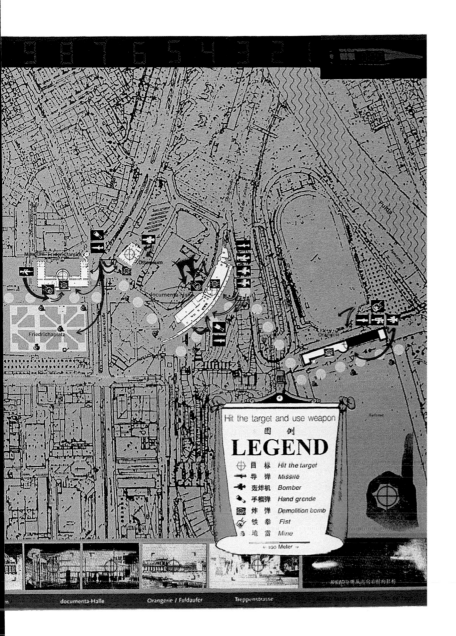

*Invitation*, as the critic Dai Jinhua observed,
  exposed two widely experienced and accepted
  cultural realities which we have to keep secret.
  The first is known to everyone in the art world. . . .
  For Chinese artists, the logical realization of
  "marching toward the world" means arrival at the
  "world" / Europe-America / the other shore.
  And what is not convenient to speak about is that
  this means the arrival of more curators and
  abundant funds for creation. The second [cultural
  reality] . . . is that in the arena of international
  cultural exchange an invitation letter from an
  overseas cultural organization or activity means an
  extraordinary event. In China, residence and the
  possibility of going in and out of the country are
  under [government] control. That is why an
  invitation letter from overseas plays the role of the
  magic password "open sesame." It brings, if not
  other possible treasures, at least a hard-won
  opportunity for Chinese to go and visit other
  countries. The letter itself is equal to certain
  success and status. . . . The narrow space of
  Chinese social reality made the expectation of
  "going abroad" not only a question about honor
  and a dream, but the issue of "to be or not to be."
  That is why the Invitation letters made great trouble.[1]

Beyond being part of the anecdotal history of contemporary Chinese art, the whole plot is important as conceptual art. It highlights the extent to which Chinese artists have been excluded from the major international art exhibitions, and illustrates their eagerness to be a part of the seemingly endless round of biennials and triennials. Hong Hao created a print to commemorate it, *Kassel City Defence Vertical View Map* (1998; fig. 100). Like his *Selected Scriptures series*, the print demonstrates the artist's fascination with maps. Here he has superimposed vengeful fantasies over the structure of a real map; in the *Scriptures* series, he distorted the map itself.

1.  Dai Jinhua, "Ravings or Stir-Makings," in Yan Lei, *H-S Express.*

# Sui Jianguo

Sui Jianguo, *Made in China*, 2002
Five pieces, resin; each 60 x 35.5 x 80 cm
Jean-Marc Decrop Collection

What do people outside of China know of China's contemporary sculptural arts? Most people will have seen very little that would be termed "high art," and yet they will have handled numerous sculptural objects produced in China, in the form of cheap toys and tchotchkes. In recognition of this, Sui Jianguo (b. 1956), a senior artist in the Sculpture Department of the Central Academy of Fine Arts in Beijing, has produced a series of red dinosaurs with *Made in China* boldly emblazoned on their chests. They are a metaphor for China, grown into an economic colossus based on the export of cheap mass-produced toys and other consumer goods. The smaller, eighty-centimeter Made in China dinosaurs (fig. 101) were manufactured at a plastics factory, where the manager helpfully attempted to convince Sui that Made in China should be written in tiny letters and hidden. Sui also created a few models of dinosaurs each over three meters tall and fabricated from painted fiberglass (fig. 102).

A leading member of China's New Sculpture Movement, Sui Jianguo bears a large share of the responsibility for helping China's contemporary sculpture find its own voice. Of all the contemporary art movements in China, that of sculpture perhaps most deserves to have the word "new" in its title. Throughout China's dynastic history, sculpture was considered a craft rather than a fine art, because its production involves physical labor. Sculptors first began to break through this prejudice in the early twentieth century, when students traveled to Europe to study art, and returned believing in sculpture as a fine art. For much of that century, however, the European techniques of realism were used uncreatively in the production of public monuments, mostly massive statues of Mao and Socialist Realist images of idealized workers, peasants, and soldiers. Only since the end of the Cultural Revolution has

Fig. 102. Sui Jianguo, *Made in China*, 1999. Painted fiberglass, approx. 320 x 200 cm.

Fig. 101. Sui Jianguo, *Made in China*, 2002. Resin, 60 x 35.5 x 80 cm. Jean-Marc Decrop Collection.

sculpture taken its place as a vehicle for personal expression. In his early works, Sui Jianguo side-stepped the realism that has dominated twentieth-century Chinese sculpture until recently, looking to what would widely be considered crafts for inspiration. In the 1970s and 1980s, the Chinese government undertook many important archaeological excavations, and published the findings. Sui Jianguo was impressed by the technique and beauty of the prehistoric jades and early metalwork. In the early 1990s he began a series of projects in which he combined metal and stone. Into jagged chunks of marble he embedded an overlaid metal web, recalling the crackle-glazed wares of a thousand years ago, or the ancient bronzes that were inlaid with gold, silver, and turquoise. He made sculptures from river boulders: they appear to have fractured and then been repaired by metal "stitches," reminiscent of the stapling technique used to repair pottery vessels or large stone tablets. Other river boulders he enmeshed within nets of welded rebar (see fig. 18). In all of these stone and metal pieces, the metal carefully shaped over the rock draws attention to the natural form, and affirms the artist's willingness to accept nature's primacy. Sui's interest in the natural structure contrasts dramatically with almost all earlier Chinese sculpture.

Always exhibiting a talent for combining materials and form, Sui Jianguo then produced works that were more conceptually oriented. With his *Study on the Folding of Clothes* series (1998; figs. 103, 104), he began an examination of the place of Chinese sculpture in the world sculpture tradition, explicating the distant origin of Chinese Socialist Realist sculpture in Greece and in Renaissance Italy. The simple addition of a Mao jacket and pants to the plaster reproduction sculptures used for teaching in China's art academies highlights the shallowness of the changes to the sculptural tradition effected by Socialist Realism. There is also an in congruity to clothing such glorious bodies in the drab, shapeless Mao suit (ironically, modeled after a European prototype), and perhaps a comment on the impossibility of commanding uniformity through conformity of dress: for decades prior to the 1980s, everybody, no matter what age, sex, or occupation, wore a Mao jacket and pants. Having examined China's archaeological sculpture tradition and probed the roots and significance of Socialist Realist sculpture, Sui has more recently found mass-produced commercial sculptures a source of inspiration.

Fig. 103. Sui Jianguo, *Study on the Folding of Clothes*, 1998. Fiberglass, 230 cm high.

Commenting on the implications of his work, Sui said:

> The reason I enlarged the toys to such an enormous size [for the Made in China series] is to highlight the political economic system behind [the production of the toys]. Dinosaur toys are designed by some company from a Western country, and produced in China, then commercially distributed to the whole globe. It is the result of transnational capitalist production. The model of "design [overseas], manufacture from raw materials [in China], and selling back [to the overseas market]" is exactly the economic model of developing countries. . . . I'm also wondering, when Western audiences see the huge dinosaur, whether they would realize that it is exactly the result of transnational capital operation.[1]

1. Sui Jianguo, to Kela Shang, e-mail communication, 23 June 2004; translated by Shang.

Fig. 104. Sui Jianguo, *Study on the Folding of Clothes*, 1998. Installation view, Third Shanghai Biennale, 2002.

Fig. 10(
paper,

propelled him onto the exhibition circuit: in 2002 he participated in six international biennials (not including Documenta XI).

For the Fifth Shenzhen International Public Art exhibition in 2003, Yan, turning to broader issues of control, walled off a choice parcel of open space atop a hill (*The Fifth System*; fig. 111). Supposedly this action was intended to protect the land against development, balancing the good of the public against the developers' political and financial clout. In addition, the ease with which the artist was allowed to construct the wall highlighted the haphazardness of urban planning in rapidly expanding Shenzhen. The most obvious result, however, is that the wall will prohibit public access for its two-year tenure as a work of art: only Yan Lei has the key. With the ability to control prime public land, command the construction of an imposing wall, and deny access, the artist has come into measurable power, far more concrete than that usually provided by an exhibition opportunity.

1. Designed by the Latvian engineer, Walter Zapp (1905–2003), the first subminiature camera, the VEF Minox, was widely used for spying.
2. While the two paintings are superficially similar, the media, style, and above all the motivations are different. Thus, if we take the artist's duplication of the image to be an aggressive act, it is in the end only an amplification of the game that already is implicit.

In the middle
shared the ex
curators visiti
called it "see
too, involved
presenting th
awaiting a ju
the power rel
Chinese artis

When Yan Le
inventors of a
reminiscent c
doctor." The
and yet dispa
to evaluate o
judgment. Th
work is secre
process ever
our future. Ye
effect of turr
perhaps by tl
Lei's set of p
106), expose
existed betw
and brings sc

Yan Lei has e
career, focus
uneven relat
arranged, thr
beaten up, p
description o
know Yan Le
performance
documented
injuries he su
dental recorc
the hierarchi

Fig. 109. Yan Lei, *The Beijing Negotiation Building*, 2000. Acrylic on canvas, 150 x 217 cm. Collection of the Modern Chinese Art Foundation, Gent, Belgium.

Fig. 111. Yan Lei, *The Fifth System*, 2003. Installation, with public land, construction material, and spray paint; wall 1.8 m high; land approx. 90 m across. *The Fifth System: Public Art in the Age of "Post-Planning"* exhibition, Shenzhen.

Fig. 113. Yin Xiuzhen, *Ruined City*, 1996. Installation, with tiles, cement, and furniture, 57 x 175 x 175 m.

much of the time, rarely touching ground in Beijing. The suitcase works continue her interest in cityscapes, but in a new ready-to-travel, peripatetic-artist mode: instead of crating and shipping her work, she simply checks her luggage.

There is also, of course, a deeper rationale for the suitcases. "Cities nowadays," she says, "are more and more alike, so I started to use clothes to make cities by putting them in a suitcase. . . . I think collecting other people's clothes is like collecting everybody's experiences; I put everybody's experience together to make an artwork."[1] In the homogenized cities that result from globalization, it is the individual experience that is the measure of differentiation.

The idea of gathering the experiences of different people into the suitcases led Yin Xiuzhen to consider making particular cities. For the unfinished *Portable Cities* series (2001– ), she shapes the dominant features of cities she visits—including Beijing (fig. 115), Lhasa, Singapore, Minneapolis, and Paris—out of clothing donated by local people. An office block might be cut from a flowered blouse, a crane from a nylon stocking, a river from a plaid shirt. The awkwardly formed structures and recycled materials

underscore the fragility and transient nature of the human component of the global city. To further differentiate her *Portable Cities*, Yin Xiuzhen embeds a tape recorder within each, to play music characteristic of the particular city.

*Portable City—Shenzhen* (2003; fig. 116) bristles with cranes. Shenzhen is China's fastest growing metropolis and its population mushroomed from three hundred thousand people in 1980 to 4.6 million by late 2003.[2] In 1980 Deng Xiaoping catalyzed the metamorphosis from fishing village to giant manufacturing and trade center when he declared Shenzhen one of four Special Economic Zones, areas where foreign investment was first permitted under his Open Door Policy. Unsurprisingly, the emphasis on rapid growth has made city planning a haphazard practice and the cranes continue to proliferate. As noticeable as the frenzied building is the youth of the residents: most people moving into Shenzhen are under thirty. Yin Xiuzhen's choice of gaily colored and patterned fabrics and the music she selected reflect that demographic.

1.  Ai Weiwei, ed., *Chinese Artists*, 132.
2.  Chuihua Judy Chung, Jeffrey Inaba, Rem Koolhaas, and Sze Tsung Leong, eds., *Harvard Design School Project on the City: Great Leap Forward* (Cologne: Taschen, 2001), 121; *Demographia* (Belleville, Ill.: Wendell Cox Consultancy). http://www.demographia.com /db-sz2003.htm (accessed 23 June 2004).

Fig. 114. Yin Xiuzhen, *Suitcases*, 2000. Mixed media installation, with suitcases, used clothing, and lights. Earl Lu Gallery, Singapore.

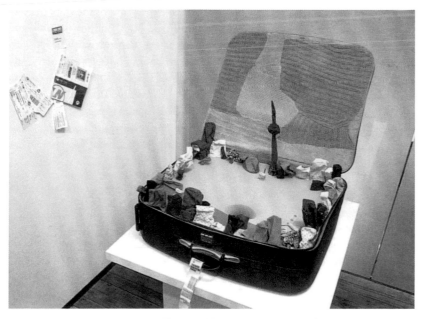

Fig. 115. Yin Xiuzhen, *Portable City—Beijing*, 2000. Mixed media installation, with map, clothing, magnifying glass, suitcase, and light, 85.1 x 127 cm.

# Zhou Tiehai

Zhou Tiehai, *Rongxi Studio*, 2001
Acrylic on canvas, 200 x 94 cm
Collection of the artist

In 2000 Zhou Tiehai began producing copies of famous European portraits by such artists as Albrecht Dürer (1471–1528), Francisco de Goya (1746–1828), and Giorgione (1478?–1510), replacing the often rather self-important faces with camel faces. These constitute the *Placebo* series (fig. 117),which also includes portraits of art-world figures that are important to him, such as Harald Szeemann, the curator who chose his work for the Forty-eighth Venice Biennale, and Uli Sigg, who has collected numerous paintings by him. A year later Zhou began the *Tonic* series, copies of monuments of Chinese painting. One of the first he produced was *Rongxi Studio* (2001; fig. 118), a copy of a work of the same name, now in the Palace Museum, Taipei, Taiwan, that was painted in 1372 by Ni Zan (1301–1374). For over a thousand years, Chinese painters learned their art by copying earlier masterworks. Zhou Tiehai follows that method ironically, hiring an assistant to do the painting for him. Having chosen to apply paint using an airbrush, Zhou dryly observes that his choice makes it difficult to copy the early masters' brushwork—perhaps the most crucial and distinctively personal element of traditional Chinese painting.

When the Ise Foundation Gallery in New York showed Zhou's reproductions of Chinese classics in *The Artist Isn't Here* exhibition in 2001, ShanghART Gallery in Shanghai held a concurrent solo exhibition also titled *The Artist Isn't Here* and consisting of an assortment of Zhou Tiehai's works referencing international art trends. The (quite reasonable) expectation was that his regular audience, familiar with his sophisticated and eclectic artistic vocabulary , would seek him out in his hometown of Shanghai; his new audience in New York would look to him as a representative of Chinese art, and would be disappointed with his work if they could not find Chineseness there.

Both the *Placebo* and *Tonic* series are responses to problems the artist has observed in the art world. Critical of both the Chinese and the Western reception of contemporary art produced by Chinese artists, he has said,

> It is okay to play, it is okay to give a severe warning to self-centered people, and this is what my works "placebo" and "tonic" are trying to do. It is not okay to respect "people." Contemporary art is not a tool for education, and Chinese contemporary art is certainly not some derivative and fashionable alternative, but a piercing through of mankind's destiny amid modern and so-called post-modern anxiety, amid the West's rationality and self-respect, the East's intuition and unsophistication.[1]

1.  Ai Weiwei, ed., *Chinese Artists*, 152.

Fig. 117. Zhou Tiehai, *Placebo—Ms. Camel in Red Clothes II*, 2000. Acrylic on canvas, 290 x 205 cm. Collection of the artist.

Fig. 118. Zhou Tiehai, *Rongxi Studio*,
2001. Acrylic on canvas, 200 x 94 cm.
Collection of the artist.

# CHECKLIST OF THE EXHIBITION

## PART ONE: THE WEST THROUGHT A POLITICAL LENS

**1. Hong Hao**
*Selected Scriptures, Page 2001: New World No. 1*, 2000
Silkscreen print, 55 x 79 cm
Christophe W. Mao Collection
Fig. 50

**2. Hong Hao**
*Selected Scriptures, Page 2051: New World No. 2*, 2000
Silkscreen print, 55 x 75 cm
Christophe W. Mao Collection
Fig. 51

**3. Huang Yong Ping**
*Bat Project I, II, III Memorandum*, 2001–2004
Installation, with photographs and paper, approx. 6 x 1.5 x 4 m
Collection of the artist
Figs. 57, 58 (details)

**4. Wang Du**
*Youth with Slingshot*, 2000
Resin, fiberglass, acrylic paint, 120 x 190 x 110 cm
Fashion Concepts, Inc. Collection
Fig. 59 and frontispiece

**5. Xing Danwen**
*disCONNEXION* series: a3, 2002–2003
Chromogenic print, 148 x 120 cm
Collection of the artist
Fig. 65

### 6. Xing Danwen
*disCONNEXION* series: a6, 2002–2003
Chromogenic print, 148 x 120 cm
Collection of the artist
Fig. 66

### 7. Xing Danwen
*disCONNEXION* series: b2, 2002–2003
Chromogenic print, 148 x 120 cm
Collection of the artist
Fig. 67

### 8. Zhang Huan
*My New York*, 2002
Video
Collection of the artist

### 9. Zhang Huan
*My New York: #1*, 2002
Chromogenic print, 100 x 150 cm
Collection of the artist
Fig. 70

### 10. Zhang Huan
*My New York: #4*, 2002
Chromogenic print, 150 x 100 cm
Collection of the artist
Fig. 71

### 11. Zhou Tichai
*Civilization*, 2004
Set of three paintings, acrylic on canvas, 200 x 510 cm overall
Collection of the artist
Figs. 72, 73 (details)

## PART TWO: CULTURAL MÉLANGE

### 12. Qiu Zhijie
*Grinding the Stele*, 2001
Video
Collection of the artist
Fig. 76 (detail)

**13. Qiu Zhijie**

*Grinding the Stele*, 2001

Ten ink prints on handmade paper, mounted as five
hanging scrolls; each scroll, 225 x 77.5 cm

Ethan Cohen Collection

Fig. 77 (detail)

**14. Qiu Zhijie**

*The West*, 2000

Interactive CD-ROM

Collection of the artist

Figs. 78–83 (details)

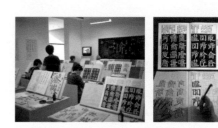

**15. Xu Bing**

*Square Word Calligraphy Classroom*, 1994–1996

Mixed media interactive installation: twelve desk,
chair, and bookrest sets; blackboard; brushes, ink,
and inkstones; copybooks and tracing books; video

Collection of the artist

Figs. 85, 86 (detail)

**16. Xu Bing**

*A Case Study of Transference*, 1994

Video installation

Collection of the artist

Figs. 87, 88 (details)

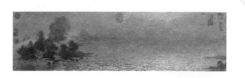

**17. Zhang Hongtu**

*Wang Shen—Monet*, 1998, artist's inscription and
seals added 2002

Oil on canvas, 71 x 244 cm

Collection of the artist

Fig. 95

**18. Zhang Hongtu**

*Shitao—van Gogh #7*, 2004

Oil on canvas, 183 x 81.3 cm

Collection of the artist

Fig. 97

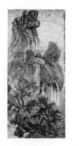

**19. Hong Hao and Yan Lei**
*Invitation*, 1997
Three pieces: envelope, gallery floor plan, invitation, paper, 11 x 22 cm,
21 x 29.7 cm, and 29.7 x 21 cm
Yan Lei Collection
Figs. 98, 99 (detail)

**20. Hong Hao**
*Kassel City Defence Vertical View Map*, 1998
Silkscreen print, 56 x 76 cm
Christophe W. Mao Collection
Fig. 100

**21. Sui Jianguo**
*Made in China*, 2002
Five pieces, resin, 60 x 35.5 x 80 cm each
Jean-Marc Decrop Collection
Fig. 101

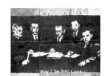

**22. Yan Lei**
*May I See Your Work?* 1997
Set of six paintings: one piece, mixed media on canvas, 156 x 195 cm,
five pieces, acrylic on paper, each 88 x 67 cm
Jean-Marc Decrop Collection
Fig. 106

**23. Yan Lei**
*The Curators*, 2000
Set of three paintings, oil on aluminum sheet on canvas,
135 x 230, 78 x 38, and 73 x 56 cm
Jean-Marc Decrop Collection
Fig. 110

**24. Yin Xiuzhen**
*Portable City—Shenzhen*, 2003
Mixed media installation, with clothing, suitcase, light, and sound;
approx. 145 x 82 x 60 cm (open)
Collection of the artist
Fig. 116

**25. Zhou Tiehai**
*Rongxi Studio*, 2001
Acrylic on canvas, 200 x 94 cm
Collection of the artist
Fig. 118

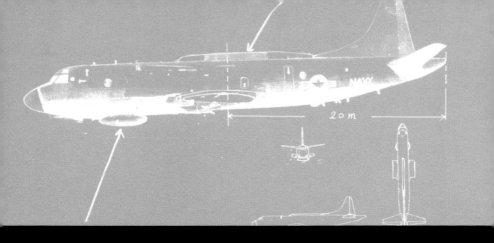

BAT PROJECT HISTORY by Huang Yong Ping

AN INTRODUCTION TO SQUARE WORD CALLIGRAPHY by Xu Bing

WILL: A SILENT MOVIE by Zhou Tiehai

APPENDIXES

**November 5, 2001**

The entire stainless steel frame of the *Bat Project* was completed at a local factory.

**November 15, 2001**

The French consul general in Guangzhou conveyed verbally to representatives of the He Xiangning Museum the opinion of the French embassy in Beijing—that Huang's *Bat Project* should not be exhibited—with the request that the museum stop the installation's progress on technical grounds. The museum representatives were puzzled by the decision of the French embassy; there had been a considerable investment of cash and effort, and certainly there could be no technical cause for the change in plans.

**November 21, 2001**

With the basic construction done at the local factory according to the original plan, *Bat Project* was being prepared for transport to the exhibition venue, where it would be spray painted and completed. But the installation progress ended right there.

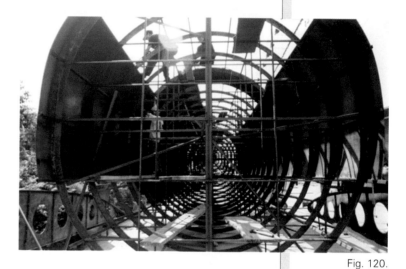

Fig. 120.

**November 26, 2001**

Nguyen informed Huang that certain staff members at the French embassy raised the objection that his sculpture could lead to diplomatic problems between the French, Chinese, and American governments, and it would prove disadvantageous to French foreign policy. The embassy staff felt the installation should be removed from the exhibition, but they would not provide a written explanation for the decision. Nguyen emphasized the decision was made by some French politicians and it did not represent the opinion of the French Ministry of Culture, whose staff disagreed with the decision.

**November 30, 2001**

A working lunch was convened to discuss a solution to the problem of Huang's installation. It was attended by Patrick Michel (cultural attaché

Fig. 121.

at the French embassy in Beijing), Raymond Rocher (cultural attaché at the French consulate in Guangzhou), Nguyen, Huang, Chen Jian, and Le Zhengwei (deputy directors of the He Xiangning Museum), Luan Qian (assistant administrator at the same museum), Huang Zhuan (Chinese curator of the exhibition). Michel verbally proposed the formula, "4 + 1". Four of the five French artists would show in the exhibition, and Huang would exhibit in a separate venue with a separate published brochure. Michel indicated that this solution was the result of discussion between the French embassy and the Chinese government, but that it did not represent his view. Huang accepted the proposed solution and asked that the two exhibitions be held concurrently. After the meeting, the material and the artist's interview on Huang's installation were removed from the exhibition catalogue.

### December 7, 2001

The He Xiangning Museum received the authorization document from the Chinese Cultural Bureau that listed the fourteen artists from China and four from France, without mention of the "4 + 1" solution. Nguyen contacted the French embassy by phone and elicited the response from Michel that the matter was now in the hands of the Chinese Foreign Affairs Department and they could not very well interfere. From then on, the plane installation, largely completed, was shelved.

### December 10, 2001

The French exhibiting artist Daniel Buren drafted a letter of protest:

> We, the collective body of artists invited to the Fourth Shenzhen Sculpture Exhibition, unanimously confirm the following: The wanton removal of the work of the Chinese artist Huang Yong Ping, a French national, from the exhibition is an intolerable, unjust, and laughable action. This has harmed not only those directly involved, but also artists participating in this exhibition. We therefore consider that the precipitous cancellation of this work, already approved by those concerned, and the fact that the originating cause of its rejection was the Office of Foreign Affairs of the French government, is a gross insult to freedom of expression. In light of this, such an action deserves the strictest possible censure.

The letter was also signed by the exhibiting artists representing China: Wang Jianwei, Wang Guangyi, Gu Dexin, Xu Tan, Sui Jianguo, Yin Xiuzhen, Shi Hui, Zhang Yonghe, and Zeng Li.

### December 11, 2001

The letter of protest was changed to read:

> We, the collective body of artists invited to the Fourth Shenzhen Sculpture Exhibition, unanimously confirm the following: The wanton removal of the work of the Chinese artist Huang Yong Ping, a French national, from the Exhibition is an intolerable, unjust, and laughable action. This has harmed not only those directly involved, but also artists who have participated in this Exhibition. We therefore consider that the precipitous cancellation of this work, already approved by those concerned, regardless of the cause for the action taken, is a gross insult to freedom of expression. In light of this, such an action deserves the strictest possible censure.

The French artists at the exhibition who signed letter were Daniel Buren, Anne and Patrick Poirier, and Radi Designers.

Jieming, Wang Youshen, Weng Fen, Zhang Dali, Lin Yilin, Gu Dexin, Wang Jianwei, Sui Jianguo, Yu Fan, Zhan Wang, Liang Juhui, Ni Weihua, Wang Wei, Zhang Hongtu, Huang Yihan, Wei Qingji, Song Yongping, Rong Rong, Ye Yongqing, Feng Mengbo, Zhu Jinshi, Hong Hao, Hu Youben, Wang Luyan, Chen Lingyang, Sun Liang, Chen Wenbo, Ma Liuming, Zhang Xiaogang, Zeng Hao, Yue Minjun.

*Ershiyi shiji wanqiu baodao* [Twenty-first century global report] published "*Bianfu jihua geqian Guangzhou*" [*Bat Project* runs aground in Guangzhou], by the reporter Ning Weiyang.

**November 17, 2002**

Wu Hung and Feng Boyi (curators of the Guangzhou Triennial) wrote a letter to Huang that included the following paragraph:

> As curators of this exhibition, it is our responsibility to explain the reason for and the circumstances under which your work was removed from the exhibition; yet, due to the lack of textual materials, we are unable to provide you with a precise, detailed account of the situation. What we do know is that this incident arose in the arena of international diplomacy. Although the French diplomatic staff denied involvement in the incident, we understand the French consulate in Guangzhou contacted the local Chinese authority and, invoking your status as French national, negotiated for the cancellation of *Bat Project II*. We also learned both the French and the U.S. embassies sent word of your installation to the Chinese Ministry of Foreign Affairs. The American consulate sent staff to the exhibition venue to photograph both the preparatory installation and subsequent removal of *Bat Project II*. The Ministry of Foreign Affairs did not directly contact us in

Fig. 127.

Fig. 128.

Fig. 129.

any way, nor did they make any attempt to look into the meaning
and intention of your artwork before canceling it, under strictly
administrative order. We believe this line of action is wrong
and disadvantageous to the development of Chinese art and the
global image of China itself.

**November 18, 2002**

"Spy Plane Artwork Runs into Trouble," by Tom Mitchell, the Guangzhou
correspondent for the *South China Morning Post*, is published in Hong Kong.

**November 28, 2002**

"L'avion Détourné de Yongping censure" is published in the French journal
*Libération* by Pierre Haski, a correspondent in Beijing.

**April 2003**

*Bat Project II* was acquired by the Guy & Myriam Ullens Foundation.

**June 15, 2003**

Sketches, photographs, documents, models, and publications regarding *Bat
Project I & II* were shown at *Zone of Urgency*, Fiftieth Venice Biennale.

**September 17, 2003**

A representative from the He Xiangning Museum telephoned Huang to discuss
the possibility of repairing the unfinished *Bat Project I* that he had
created in 2001. In early 2002, Huang had promised to donate *Bat Project
I* to the He Xiangning Museum.

**October 6, 2003**

Gu Zhenqing, an independent curator based in Beijing, invited Huang to
participate in *Left Wing: An Exhibition of Chinese Contemporary Art*, to be
held at the Leftbank Community in Beijing. The exhibition was funded by
Beijing Wanliu Land Development Co., Ltd. [Wanliu Xinxing Fangdochan
Kaifa Youxian Gongsi], which also provided an exhibition space. The con-
cept for the *Left Wing* exhibition was derived from a well-known advertis-
ing slogan in Beijing used by the land developer Lin Jian: "When the world
turns right, turn left!" Huang thought that this exhibition offered a good
opportunity to realize *Bat Project III*, the right wing of the aircraft
that had remained unfinished since 2002.

**October 15, 2003**

Huang received an invitation from Leftbank Community to visit the exhibi-
tion space in Beijing. In the meantime, he met their general manager Lin
Jian to discuss *Bat Project III*. It was envisaged that the artwork would
be installed in the Leftbank Community South Plaza.

**November 23, 2003**

Huang received an invitation from the He Xiangning Museum and arrived in
Shenzhen to visit the exhibition space for *Bat Project I*. On the same day,
Huang and Lin Jian signed an agreement at the Shenzhen Airport for the
inclusion of Huang's work entitled *Right Wing Memorandum* in the *Left Wing*
exhibition. Meanwhile, Lin Jian agreed to sponsor the installation with
RMB ¥100,000 (approximately US$12,700).

**December 2, 2003**

*Bat Project I* began to be repaired and reinstalled in Shenzhen. On the
same day, the organizer of the *Left Wing* exhibition commissioned the props
department of the Beijing Film-Making Company to start building the right
wing for *Bat Project III*.

**December 13, 2003**

*Bat Project I* was reinstalled on the front lawn of the He Xiangning Museum in Shenzhen two years after it was censored.

**December 15, 2003**

Huang Yongping, Gu Zhenqing, and Lin Jian met at the Beijing Leftbank Community to discuss production expenses and installation details for *Bat Project III*. Lin indicated the RMB ¥100,000 of funding would be paid after the completion of the artwork. They also discussed the fact that, if the artwork were placed in the South Plaza, it might block the busy footpath and permission might be needed from the Beijing City Administrative Bureau [Beijing chengguanju]. Therefore, it was suggested that the work be installed in the North Plaza.

**December 17, 2003**

Huang and the Leftbank Community's engineer inspected the exhibition space again. They came to the conclusion that it would be impossible for the crane to come near the passageway of the North Plaza, and that there was a potential ground problem with that location. It was therefore agreed to go back to the original idea of installing the work in South Plaza. To solve the ground problem, Huang decided to rent a crane to suspend the plane wing vertically for the duration of the exhibition.

**December 29, 2003**

The basic construction of the plane wing was finished at the props department of the Beijing Film-Making Company. It measured 15.8 meters long, 6.5 meters wide, and 2.5 meters high, and weighed 8 tons. The supporting wall for the wing was ready to be removed for transportation. At 7:00 p.m., the curator Gu Zhenqing received a notice from the Beijing Wanliu Land Development Co., Ltd. regarding the cancellation of *Bat Project* from the *Left Wing* exhibition, which was to open on 30 December, 2003. The

Fig. 130.

130

Fig. 131.

letter read: "With reference to the safety and the installation problems of Huang Yongping's work, we still have not received any written document from your end proposing a proper solution. Although we have put forth much effort, it has all been in vain. We regret to inform you of the cancellation of this project. Please convey this message to the artist."

At 9:00 p.m., Huang and Gu arrived at the Leftbank Community to meet Lin Chuan, the marketing manager of Beijing Wanliu company and the brother of Lin Jian. Lin Chuan excused his brother, who was in hospital. The banning of *Bat Project III* was unavoidable.

**December 30, 2003**

Huang published an open letter regarding the safety issues connected with *Bat Project III*:

At 7:00 p.m. on 29 December,2003, my work *Bat Project III* was banned from the exhibition by the Beijing Wanliu Land Development Co., Ltd.

The crane was ready and all the preparation work had been completed. Initially, it was planned to transport the work to the Leftbank Community on 30 December, 2003 at 2:00 a.m. Prior to that, related issues such as exhibition location and safety had been solved with representatives of the Leftbank Community. Nevertheless, the holding company of the Beijing Leftbank Community, Wanliu Land Development Co., Ltd., cancelled the project due to its potential safety problems, which is unacceptable. When we further inquired about the reason behind the ban, the representatives from the Leftbank Community claimed that the first reason was the engineering problem, and the second concerned the political risk. Since the latter is hard to describe through written language,

© XU BING, 2001

必须

W

I

L

L

A SILENT MOVIE BY ZHOU TIEHAI

Fig. 141.

Fig. 142.

| 第二幕 | 咖啡馆 |
|---|---|
| **Act Two** | **The Cafeteria** |

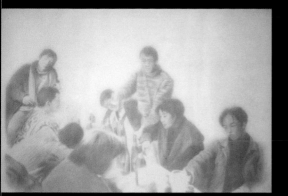

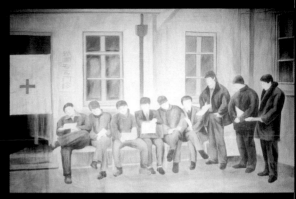

Fig. 143.                                    Fig. 144.

| （中景） | 咖啡馆内七八个人围坐在一起，气氛热烈。 |
|---|---|
| **Middle-distance shot:** | **Inside the cafeteria, a few people are having a discussion.** |
| （近景） | 一个人很激动在说话。 |
| **Close-up:** | **One of them explains:** |
| （字幕） | 要不断办展览，让大家都注意我们。 |
| **Subtitle:** | **We must continue having exhibitions to draw attention to ourselves.** |
| （近景） | 另一个人也很激动在说话。 |
| **Close-up:** | **Another one exclaims:** |
| （字幕） | 什么展览都要参加，只要有机会就上。 |
| **Subtitle:** | **No matter what kind of exhibition, I'll take part if I have the chance.** |
| （近景） | 一位女艺术家说。 |
| **Close-up:** | **A female artist says:** |
| （字幕） | 要和批评家，记者搞好关系。 |
| **Subtitle:** | **We must establish close relationships with critics and journalists.** |

| 第三幕 | 看病 |
|---|---|
| **Act Three** | **In the Hospital** |

| （特写） | 一块牌子上面写："外国专家门诊"。 |
|---|---|
| **Close-up of a sign that reads:** | **Foreign Doctor's Outpatients** |
| （全景） | 医院里，有许多人在等待外国专家的诊断，有一个护士在叫号，一个病人走进去。 |

Fig. 145.                                    Fig. 146.

| | |
|---|---|
| **Panoramic shot:** | There are many patients waiting for their medical checkup by the foreign doctor. A nurse calls a number. A patient goes in. A nurse calls a number. A patient goes in. |
| （字幕） | 15 分钟之后。 |
| **Subtitle:** | 15 minutes later. |
| （全景） | 第一个病人出来，第二个病人进去。 |
| **Panoramic shot:** | The first patient comes out and a second patient goes in. |
| （字幕） | 15 分钟之后。 |
| **Subtitle:** | 15 minutes later. |
| （全景） | 第二个病人出来，第三个病人进去。 |
| **Panoramic shot:** | The second patient comes out and a third patient goes in. |
| （字幕） | 15 分钟之后。 |
| **Subtitle:** | 15 minutes later. |
| （全景） | 第三个病人出来，第四个病人进去。 |
| **Panoramic shot:** | The third patient comes out, and a fourth patient goes in. |
| （近景） | 诊室内，外国专家先看看 X 光片，并向病人询问病历，用听筒听病人的心脏，又量了一下血压。 |
| **Close-up:** | Inside the room a foreign doctor examines an X-ray and asks for the patient's chart. She listens to his heart through a stethoscope and measures his blood pressure. |
| （中景） | 护士叫号。 |
| **Middle-distance shot:** | The nurse calls a number. |
| （字幕） | 下一个。 |
| **Subtitle:** | Next patient. |
| （全景） | 诊室外病人焦急地等待着。 |
| **Panoramic shot:** | Outside the hospital room, the patients are waiting anxiously. |

# 第四幕          艺术导游
# Act Four          A Guided Tour

| | |
|---|---|
| （全景） | 一名导游对三，四个外国人宣布日程安排。 |
| **Panoramic shot:** | A guide announces the schedule to a group of foreigners. |

Fig. 147.

| | |
|---|---|
| （字幕） | 上午先看 **A** 的作品，再看 **B** 的作品，下午看 **C** 的作品，再看 **D** 的作品，晚上去 **E** 家。 |
| **Subtitle:** | **This morning we'll go to A's home to see his works. Then we'll see B's work. In the afternoon, we'll go to see C's works, and then D's works. We'll see E's works this evening.** |
| （中景） | 一外国人翻看手中旅游指南。 |
| **Middle-distance shot:** | **A foreigner leafs through his guidebook.** |
| （字幕） | 我还想看 **X** 的作品。 |
| **Subtitle:** | **I want to see X's work.** |
| （中景） | 导游解释说。 |
| **Middle-distance shot:** | **The guide explains:** |
| （字幕） | **X** 的画没意思。 |
| **Subtitle:** | **X's work isn't very interesting.** |
| （中景） | 另一外国人说。 |
| **Middle-distance shot:** | **A foreigner says:** |
| （字幕） | 我想看 **Y**。 |
| **Subtitle:** | **I want to see Y's work.** |
| （中景） | 导游说。 |
| **Middle-distance shot:** | **The guide says:** |
| （字幕） | **Y**？ **Y** 是谁？我没听说过。 |
| **Subtitle:** | **Y? Who is Y? I've never heard of him.** |
| （中景） | 一名外国人说。 |
| **Middle-distance shot:** | **Another foreigner says:** |
| （字幕） | 听说 **Z** 是才华横溢的艺术家，是否可带我们去看看呢？ |
| **Subtitle:** | **I've heard that Z is an outstanding artist. Shall we go see his work as well?** |
| （中景） | 导游说。 |
| **Middle-distance shot:** | **The guide says:** |
| （字幕） | **Z**？他住得很远，来不及了。 |
| Subtitle: | Z lives far from here，we don't have enough time |

| | |
|---|---|
| **第五幕** | **电话诉衷肠** |
| **Act Five** | **Heartfelt Calls** |
| | |
| （近景） | 一位艺术家跑到公用电话亭，打了五个电话。 |
| **Close-up:** | **An artist goes to a pay phone and makes five calls.** |
| （字幕） | 你策划的任何展览我都愿参加。 |
| **Subtitle:** | **I'll take part in any exhibition you have.** |

Fig. 148.

| | |
|---|---|
| **第六幕** | **你背叛我** |
| **Act Six** | **You Betrayed Me** |
| | |
| （近景） | 一位批评家给一艺术家打电话。 |
| **Close-up:** | **A critic is calling on an artist.** |
| （字幕） | 近日那位外地评论家在本市活动情况如何？ |
| **Subtitle:** | **How about that critic from another province? What's he doing in my city?** |
| （近景） | 艺术家对话筒说。 |
| **Close-up:** | **An artist on the phone says:** |
| （字幕） | 我按你的意思，没有接待他，只是有一个人偷偷会见了他。 |
| **Subtitle:** | **You told me not to see him and I haven't, but there is someone who went to see him on the sly.** |
| （近景） | 批评家气愤地放下电话。 |
| **Close-up:** | **The critic slams the phone down.** |
| （中景） | 批评家跑入一幢房子，看见一扇门半开着，推开一看。 |
| **Middle-distance shot:** | **Middle-distance shot: The critic runs into a house. He sees a half-open door and pushes it open.** |
| （近景） | 艺术家正和外地评论家谈话。 |
| **Close-up:** | **The artist is talking to a rival critic.** |
| （近景） | 批评家指着艺术家大吼。 |
| **Close-up:** | **The critic exclaims to the artist:** |
| （字幕） | 你背叛我！ |
| **Subtitle:** | **You've betrayed me!** |

Fig. 149.

| 第七幕 | 你们只有中医和巫术 |
|---|---|
| **Act Seven** | **You Have Only Traditional Chinese Medicine and Witchcraft** |

Fig. 150.

| （全景） | 一桌中外人士在吃饭，一个外国人对中国人说。 |
|---|---|
| **Panoramic shot:** | **A group of Chinese people and foreigners are having dinner. A foreigner says to the Chinese:** |
| （字幕） | 你们只有中医和巫术，没有艺术。 |
| **Subtitle:** | **You have only traditional Chinese medicine and witchcraft, but no art.** |
| （全景） | 门被推开，一个人走进来严肃说。 |
| **Panoramic shot:** | **The door is pushed open. A person walks in saying sternly:** |
| （字幕） | 胡说，我们有艺术。 |
| **Subtitle:** | **Nonsense! We do have art!** |
| （近景） | 外国人显得很惊讶。 |
| **Close-up:** | **The foreigner is surprised.** |
| （近景） | 这个人气氛地说。 |
| **Close-up:** | **The same person exclaims:** |
| （字幕） | 难道我们的艺术一定要配你们的胃口吗？ |
| **Subtitle:** | **Must our art live up to your standards?** |

| 第八幕 | 教父 |
|---|---|
| **Act Eight** | **The Godfather** |

| （全景） | 在一个大客厅里，许多人在跳舞。 |
|---|---|
| **Panoramic shot:** | **Many people are dancing in a large sitting room.** |
| （中景） | 在另一个房间，教父和一个人在说话。 |
| **Middle-distance shot:** | **In another room, the Godfather says to someone:** |
| （字幕） | 现在新的利害的艺术家太少，我担心后继无人。 |
| **Subtitle:** | **There are so few outstanding new artists. I'm worried about the next generation.** |

Fig. 151.

| | |
|---|---|
| （中景） | 那人默默无语。 |
| **Middle-distance shot:** | **The person remains silent.** |
| （全景） | 大客厅里人继续在跳舞。 |
| **Panoramic shot:** | **The sitting room is packed with dancing guests.** |
| （中景） | 房间里教父拉着两个人的手说。 |
| **Middle-distance shot:** | **The Godfather holds the hands of two people.** |
| （字幕） | 你们还在争吵，真让我放心不下。 |
| **Subtitle:** | **You're still quarreling.  That makes me uneasy.** |
| （特写） | 教父老泪纵横。 |
| **Close-up:** | **The Godfather starts to weep.** |

| | |
|---|---|
| 第九幕 | 梅杜萨之筏 |
| **Act Nine** | **The Raft of the Medusa** |

| | |
|---|---|
| （全景） | 十几个人在木筏上，漂泊在海上。 |
| **Panoramic shot:** | **Ten or so people are huddled on a raft floating in the sea.** |
| （近景） | 有的人已死去。 |
| **Close-up:** | **Someone has died.** |
| （近景） | 有的人在挣扎。 |
| **Close-up:** | **Someone is struggling.** |
| （近景） | 有的人在思考。 |
| **Close-up:** | **Someone is thinking.** |

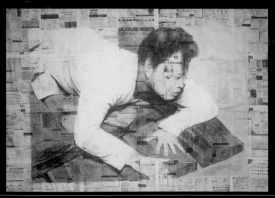

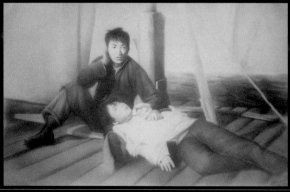

Fig. 152.                              Fig. 153.

Fig. 154.

| （字幕） | 进亦无能退亦难。 |
| **Subtitle:** | **We can't go forward. We can't go back either.** |
| （全景） | 几个人绝望在木筏上，向远出拼命呼唤。 |
| **Panoramic shot:** | **They all are desperate and shout into the distance.** |
| （字幕） | 再见吧！艺术。 |
| **Subtitle:** | **FAREWELL, ART!** |

The film was shot in 1996 for *Promenade in Asia—Sur-everyday Life-ism*, curated by Toshio Shimizu at Shiseido Gallery.

The paper works were painted by Zhou Tiehai's assistants, Chen Yiyong and Wang Haiyan.

# ARTISTS AND EXHIBITIONS

**HONG HAO**

1965     Born in Beijing
1989     Graduated from Central Academy of Fine Arts, Beijing
        Now living and working in Beijing

**Selected Solo Exhibitions**

2003     *Hong Hao*, Base Gallery, Tokyo
        *Hong Hao's Reading Room*, Chambers Fine Art, New York
2000     *Scenes from the Metropolis*, CourtYard Gallery, Beijing
        *Suspended Disbelief*, Art Beatus Gallery, Vancouver
1999     *Hong Hao—Selected Scriptures*, Canvas International Art, Amsterdam

**Selected Group Exhibitions**

2003     *Zooming into Focus: Contemporary Chinese Photography and Video from the Haudenschild
        Collection*, University Art Gallery, San Diego State University, San Diego
        *Arles Rencontres de la Photographie 2003*, Arles, France
        *Chinese Maximalism*, Millennium Art Museum, Beijing
2002     *First Guangzhou Triennial*, Guangdong Art Museum, Guangzhou, China
        *Golden Harvest: Chinese Contemporary Art*, Zagreb Fair, Zagreb, Croatia
        *Mask vs. Face*, Red Gate Gallery, Beijing
2001     *First Chengdu Biennale*, Chengdu Modern Art Exhibition Hall, Chengdu, China
        *L'Album de la famille chine*, Museum of Modern and Contemporary Art, Nice, France
        *Virtual Future*, Guangdong Museum of Art, Guangzhou, China
2000     *Third Shanghai Biennale*, Shanghai Art Museum, Shanghai
        *Basel Art Fair, 2000*, Basel, Switzerland
        *Post Material*, Red Gate Gallery, Beijing
1999     *Beijing in London*, Institute of Contemporary Arts (ICA), London
        *Five Continents and a City*, Museum of Mexico City
        *La Biennale d'Issy*, Paris
1998     *Inside Out: New Chinese Art*, P.S.1 Contemporary Art Center, and Asia Society Galleries, New York
        *Images Telling Stories: Chinese New Concept Art*, Art College of Shanghai, Shanghai
1997     *Faces and Bodies of the Middle Kingdom: Chinese Art of the '90s*, Gallery Rudolfinum, Prague, and
        Gallery OTSO, Espoo, Finland
1996     *CanTonShangHaiPeKing*, CIFA Gallery, Central Academy of Fine Arts, Beijing
1995     *New Anecdotes of Social Talk*, Art Gallery of Beijing International Air Palace, Beijing
1993     *China's New Art, Post-1989*, Hong Kong Arts Centre, Hong Kong
        *Mao Goes Pop*, Museum of Contemporary Art, Sydney
1988     *19èmes Rencontres internationales de la photographie*, Arles, France

—Stephen Whiteman

**HUANG YONG PING**

1954     Born in Xiamen, Fujian Province
1982     Graduated from Zhejiang Academy of Fine Arts (now China Academy of Art), Hangzhou
1989     Moved to Paris, where he has since resided

**Selected Solo Exhibitions***

2002     *Om Mani Padme Hum*, Barbara Gladstone Gallery, New York
1999     *Crane Legs, Deer's Tracks*, CCA Project gallery, Center for Contemporary Art, CCA Kitakyushu,
        Kitakyushu, Japan
1997     *HUANG Yong Ping*, De Appel, Amsterdam
        *Péril de mouton*, Fondation Cartier pour l'art contemporain, Paris
1996     *Trois pas, Neuf traces*, Atelier d'artistes de la ville de Marseille, Marseilles, France
1992     *La maison d'augure*, Galerie Fromen & Putman, Paris
1991     *Nous devons encore construire une grande cathédrale*, Galerie Fenster, Frankfurt
1989     *Sacrifice au feu*, L'Ecole des Beaux-arts d'Aix-en-Provence, Aix-en-Provence, France

**Selected Group Exhibitions***

2003     *Left Wing*, Leftbank Community, Beijing
        *Z.O.U.: Zone of Urgency, Fiftieth Venice Biennale*, Venice
2002     *First Guangzhou Triennial*, Guangdong Art Museum, Guangzhou, China

*Twenty-fifth São Paulo Biennale*, São Paulo, Brazil

| 2001 | *Yokohama 2001: International Triennale of Contemporary Art*, Yokohama, Japan |
| 2000 | *Third Shanghai Biennale*, Shanghai Museum of Art, Shanghai |
| 1999 | *Kunstwelten im Dialog*, Museum Ludwig, Cologne, Germany |
| | *Jean-Pierre Bertrand et Huang Yong Ping*, French Pavilion, *Forty-eighth Venice Biennale*, Venice |
| 1998 | *Inside Out: New Chinese Art*, P.S.1 Contemporary Art Center, and Asia Society Galleries, New York |
| | *Hugo Boss Prize Exhibition 1998*, Guggenheim Museum Soho, New York |
| 1997 | *Cities on the Move*, Vienna Secession, Vienna |
| 1995 | *Huang Yong Ping*, Galerie des cinq continents, Musée national des Arts d'Afrique et d'Océanie, Paris |
| 1993 | *Fragmented Memory: The Chinese Avant-Garde in Exile*, Wexner Center for the Arts, Columbus, Ohio |
| 1989 | *Magiciens de la terre*, Centre Pompidou et Grande Halle de la Villette, Paris |
| | *China/Avant-Garde*, National Art Gallery of China, Beijing |
| 1896 | *Xiamen Dada*, Cultural Palace of Xiamen, Xiamen, China |
| 1984 | *Exhibition of Five Artists*, Cultural Palace of Xiamen, Xiamen, China |

* Emphasizing the most recent

—Naomi Nagano

## QIU ZHIJIE

| 1969 | Born in Zhangzhou, Fujian Province |
| 1992 | Graduated from Printmaking Department, Zhejiang Academy of Fine Arts (now China Academy of Art), Hangzhou |
| | Now living and working in Beijing |

### Selected Exhibitions Curated

| 2003 | *Post-Sense Sensitivity: Backstage*, Spectrum Children's Art Theatre, Beijing |
| 2001 | *Post-Sense Sensitivity: Carnival*, Beijing Film Academy, Beijing |
| 2000 | *Home? Contemporary Art Proposal*, International Furniture Exhibition Center, Shanghai |
| 1999 | *Post-Sense Sensibility: Alien Bodies and Delusion*, Beijing |

### Selected Solo Exhibitions

| 2003 | *UFO: Qiu Zhijie Photography / Calligraphy*, Galerie Loft, Paris |
| 2001 | *Qiu Zhi Jie Exhibition*, Gallery Gen, Koshigaya, Japan |
| | *Invisibility: Qiu Zhijie*, Ethan Cohen Fine Arts, New York |
| 2000 | *Daily Touch*, Orient Foundation, Macao |
| 1999 | *Innate Forces—Mixed Media Works by Qiu Zhijie*, Art Beatus Gallery, Vancouver |
| 1992 | *Concern to the New Life*, Museum of Zhejiang Academy of Fine Arts, Hangzhou, China |

### Selected Group Exhibitions

| 2004 | *Between Past and Future: New Photography and Video from China*, International Center of Photography, and Asia Society Galleries, New York |
| 2003 | *Alors, la Chine?* Centre Pompidou, Paris |
| | *Post-Sense Sensibility: Inside Story*, Beijing Children's Theater, Beijing |
| | *Chinese Maximalism*, Millennium Art Museum, Beijing |
| 2002 | *First Guangzhou Triennial*, Guangdong Art Museum, Guangzhou, China |
| | *Twenty-fifth São Paulo Biennale*, São Paulo, Brazil |
| | *Gwangju Biennial*, Gwangju, South Korea |
| | *Translated Acts*, Haus der Kulturen der Welt, Berlin |
| | *Re shuffle*, Shenzhen Sculpture Academy, Shenzhen, China |
| | *First Chengdu Biennale*, Chengdu Modern Art Exhibition Hall, Chengdu, China |
| 2001 | *20 Years of Experimental Ink Painting*, Guangdong Art Museum, Guangzhou, China |
| 2000 | *Power of the Word*, Faulconer Gallery, Grinnell, Iowa |
| 1998 | *Inside Out: New Chinese Art*, P.S.1 Contemporary Art Center, and Asia Society Galleries, New York |
| | *It's Me! A Profile of Chinese Contemporary Art in the 90s*, Tai Miao, Beijing |
| 1996 | *Phenomenon / Image: Video Art in China*, Gallery of China Academy of Art, Hangzhou, China |

—Kela Shang

## SUI JIANGUO

| 1956 | Born in Qingdao, Shandong Province |
| 1984 | Graduated from Shandong Art Institute |
| 1989 | Graduated from Central Academy of Fine Arts, Beijing |
| | Now living in Beijing; Associate Professor in Central Academy of Fine Arts |

### Selected Solo Exhibitions

| 1999 | *Studies of Clothes Veins*, Passage Gallery, Beijing |
| 1997 | *You Meet the Shadow of the Hundred Years*, VCA Gallery, Melbourne |
| 1996 | *Exhibition of Work by Sui Jianguo*, Hanart T Z Gallery, Hong Kong |

| 1995 | *Deposit and Fault*, New Delhi Culture Centre, New Delhi |
| 1994 | *Remembrance of Space*, CAFA Gallery, Central Academy of Fine Arts, Beijing |

**Selected Group Exhibitions**

| 2003 | *Left Wing*, Leftbank Plaza, Beijing |
| | *Today's Chinese Art*, Millennium Art Museum, Beijing |
| | *Open Time*, National Art Gallery of China, Beijing |
| | *Contemporary Sculpture of China, Korea and Japan*, Osaka Museum, Osaka, Japan |
| 2002 | *First Guangzhou Triennial*, Guangdong Art Museum, Guangzhou, China |
| | *Modernity in China 1980–2002*, Museu de Arte Brasileira, Fundação Armando Alvares Penteado, São Paulo, Brazil |
| 2001 | *Between Earth and Heaven: New Classical Movements in the Art of Today*, Museum of Modern Art, Ostend, Belgium |
| 2000 | *Exhibition of Sui Jianguo and Zhan Wang*, Galerie Loft, Paris |
| | *Fifth Lyons Biennial of Contemporary Art*, Lyons, France |
| 1999 | *Fourteenth International Asian Art Exhibition*, Fukuoka Asian Art Museum, Fukuoka |
| 1998 | *First Annual Contemporary Sculpture Exhibition*, He Xiangning Art Museum, Shenzhen, China |
| 1997 | *Dream of China—97: Chinese Contemporary Art*, Yanhuang Art Museum, Beijing |
| | *Sui Jianguo & Li Gang, Contemporary Chinese Sculpture*, Red Gate Gallery, Beijing |
| 1996 | *Reality's Present and Future—'96 Chinese Contemporary Art*, International Art Museum, Beijing |
| 1995 | *Women Site*, Beijing Contemporary Art Gallery, Beijing |
| | *Property Development*, CAFA Gallery, Central Academy of Fine Arts, Beijing |
| 1994 | *Substance and Creativity: Asian Arts and Crafts from Its Origin to Present Day*, Hiroshima, Japan |
| 1993 | *Sui Jianguo and Wang Keping Sculpture Exhibition*, Chinese Modern Art Centre, Osaka, Japan |
| | *China's New Art, Post-1989*, Hong Kong Arts Centre, Hong Kong |

—Kela Shang

## WANG DU

| 1956 | Born in Wuhan, Hubei Province |
| 1985 | Graduated from Guangzhou Academy of Fine Arts |
| 1985–1990 | Professor of Plastic Arts, Department of Research in Architecture, South China Polytechnic University |
| 1990 | Moved to Paris, where he has since resided |
| 1997–1999 | Professor, University of Vincennes, Department of Plastic Arts, |
| 1998–1999 | Professor, Art School of Brest |

**Selected Solo Exhibitions***

| 2004 | *TapisVolant*, Galerie Roger Pailhas, Marseilles |
| 2002 | *We're Smoking Them Out*, Albert Baronian Gallery, Brussels |
| 2001 | *Luxe populaire*, Le Rectangle, Lyons, France |
| | *Réalité jetable*, Rodin Gallery, Seoul |
| 2000 | *Mon kiosque*, Art & Public Gallery at FIAC, Paris |
| | *Défilé*, Deitch Projects, New York |
| 1999 | *Marché aux puces*, Art & Public Gallery, Geneva |
| 1997 | *Les Travaux du Corps*, Gate Foundation, Amsterdam |
| | *Relique*, Anne de Villepoix Gallery, Paris |

**Selected Group Exhibitions***

| 2004 | *Espai d'Art Contemporani de Castelló*, Castellón, Spain |
| 2003 | *Biennial of Ceramics in Contemporary Art*, Albisola, Italy |
| | *ATTACK*, Kunsthalle, Vienna |
| 2002 | *TOKYO TV*, Palais de Tokyo, Paris |
| | *Mirage*, Suzhou Art Museum, Suzhou, China |
| 2001 | *Ars 01*, Kiasma Contemporary Art Museum, Helsinki |
| 2000 | *Taipei Biennial*, Taipei, Taiwan |
| 1999 | *Forty-eighth Venice Biennale*, Venice |
| 1998 | *Inside Out: New Chinese Art*, P.S.1 Contemporary Art Center, and Asia Society Galleries, New York |
| 1997 | *Cities on the Move*, Vienna Secession, Vienna |
| 1995 | *L'Art Contemporain Chinoise*, Palais Bénédictin, Fécamp, and Levallois, France |
| 1989 | *China/Avant-Garde*, National Art Gallery of China, Beijing |
| 1986 | *First Experimental Exhibition*, Southern Art Salon, Sun Yat-sen University, Guangzhou, China |

* Emphasizing the most recent

—Naomi Nagano

## XING DANWEN

| 1967 | Born in Xi'an |
| 1992 | Graduated from Central Academy of Fine Arts, Beijing |

| 2000 | MFA in Photography and Related Media, School of Visual Studies, New York |
| | Lives and works in Beijing |

**Selected Solo Exhibitions**

| 2004 | *disCONNEXION*, Kiang Gallery, Atlanta, Georgia |
| 2002 | *China Avant-Garde*, Lee Ka-Sing Gallery, Toronto, Canada |
| | *Second Ping-Yao International Photo Festival*, Shanxi, China |
| 1994 | *With Chinese Eyes*, Gallery Grauwert, Hamburg, Germany |

**Selected Group Exhibitions**

| 2004 | *Between Past and Future: New Photography and Video from China*, International Center for Photography, and Asia Society Galleries, New York |
| | *The Elegance of Silence*, Mori Art Museum, Tokyo |
| | *Biennale of Sydney 2004*, Sydney |
| 2003 | *The American Effect*, Whitney Museum of American Art, New York |
| | *Alors, la Chine?* Centre Pompidou, Paris |
| | *Chinese Maximalism*, Millennium Art Museum, Beijing |
| 2002 | *First Guangzhou Triennial*, Guangdong Museum of Art, Guangzhou, China |
| 1999 | *Transience: Chinese Experimental Art at the End of the Twentieth Century*, Smart Museum of Art, Chicago |
| | *Beijing: The Revolutionary Capital*, Institute of Contemporary Arts (ICA), London |
| 1996 | *China Today* art festival, Munich, Germany |
| 1995 | *Witness*, Tokyo Gallery, Tokyo |

—Cynthia Houng

## XU BING

| 1955 | Born in Chongqing |
| 1957 | Moved to Beijing |
| 1987 | Graduated from Central Academy of Fine Arts, Beijing |
| 1990 | Moved to United States of America; now living in New York |
| 1999 | MacArthur Award, MacArthur Foundation |
| 2003 | Fukuoka Asian Culture Prize |
| 2004 | Artes Mundi Prize |

**Selected Solo Exhibitions**

| 2004 | *Xu Bing in Berlin: Sprachräume*, Museum of East Asian Art Berlin, National Gallery of Germany, Berlin |
| | *Tobacco Project*, Shanghai Hushen Gallery and Tobacco Factory, Shanghai |
| 2003 | *Xu Bing*, Fukuoka Asian Art Museum, Fukuoka, Japan |
| | *Xu Bing*, Chinese Art Centre, Manchester, England |
| 2001 | *Word Play: Contemporary Art by Xu Bing*, Arthur M. Sackler Gallery, Smithsonian Institution, Washington, D. C. |
| 2000 | *Xu Bing, Book from the Sky and Classroom Calligraphy*, National Gallery in Prague, Prague |
| 1998 | *Xu Bing*, New Museum of Contemporary Art, New York |
| | *Installation by Xu Bing*, Institute of Contemporary Arts (ICA), London |
| 1997 | *Classroom Calligraphy*, Joan Miró Foundation at Mallorca, Mallorca |
| 1994 | *Xu Bing: Recent Work*, Bronx Museum of the Arts, New York |
| 1988 | *Xu Bing: A Book from the Sky*, National Art Gallery of China, Beijing |

**Selected Group Exhibitions**

| 2004 | *Happiness*, Mori Art Center, Tokyo |
| 2003 | *Left Hand, Right Hand*, 798 Space, Beijing |
| | *The Invisible Thread: Buddhist Spirit in Contemporary Art*, Snug Harbor Cultural Center, Staten Island, New York |
| 2002 | *Fourth Shanghai Biennale*, Shanghai |
| 2001 | *Give & Take*, Serpentine Gallery and Victoria and Albert Museum, London |
| 2000 | *Biennale of Sydney 2000*, Art Gallery of New South Wales, Sydney |
| 1999 | *Animal.Anima.Animus*, P.S.1 Contemporary Art Center, New York |
| 1998 | *Inside Out: New Chinese Art*, P.S.1 Contemporary Art Center, and Asia Society Galleries, New York |
| 1995 | *China Avant-Garde Art*, Santa Monica Art Center, Barcelona |
| 1994 | *Cocido y Crudo*, Reina Sofia Museum of Art, Madrid |
| 1993 | *Forty-fifth Venice Biennale*, Venice |
| 1989 | *China/Avant-Garde*, National Art Gallery of China, Beijing |

—Jordan Miller

## YAN LEI

| 1965 | Born in Lanfang, Hebei Province |
| 1982 | Graduated from Hebei School for Arts and Crafts |